CW00485161

# LAKE DISTRICT

## A PICTORIAL CELEBRATION *Sketchbook*

*Jim Watson*

The Honeypot Deli
at Hawkshead

SURVIVAL BOOKS • LONDON • ENGLAND

Patterdale

First published 2010

All rights reserved. No part of this publication may be reproduced, stored in a retrieval system or recorded by any means, without prior written permission from the author

Text, illustrations and maps © Jim Watson 2010

Survival Books Limited
9 Bendinck Street, London, W1U 2EL, United Kingdom
Tel: +44 (0)20-7788 7644. Fax: +44 (0)870-762 3212
email: info@survivalbooks.net
website: www.survivalbooks.net

British Library Cataloguing in Publication Data
ACIP record for this book is available
from the British Library.
ISBN: 978-1-907339-09-7

Printed and bound in India by Ajanta Offset

Front cover illustration: Crummock Water

# CONTENTS

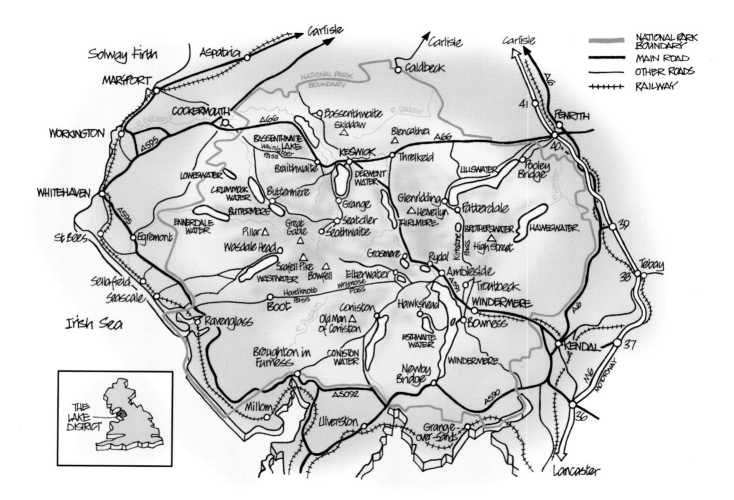

# INTRODUCTION

I was born and bred in the Lake District but left at the age of 18, never quite realising how much I was leaving behind. However, my going away has been a preparation for going back. Now, years later and after numerous return visits, my eyes are open and I can see. And to me the Lake District always looks beautiful.

Though the largest of the English National Parks, the Lake District is only about 30 miles across and 40 miles from north to south, similar in size to Greater London. Traffic on the M6 motorway speeds past in not much more than half an hour, some drivers never knowing what they're missing.

The mountains are high compared with other British mountains and the lakes are large in British terms, but on the world stage they're mere molehills and ponds. It's the variety and concentration of good things packed into such a small area that makes the Lake District so special. You never have to travel far to be moved by something.

Okay, the weather can sometimes be, as they say locally, 'a bit claggy', but as someone once said (possibly an outdoor clothing salesman), 'there's no such thing as bad weather, only inadequate clothing'. And there's always that magical moment when the rain stops, the clouds part and a sunbeam dances across a valley, making you want to cry out in appreciation and gratitude.

This book is a tour around a selection of my favourite places, some are on the main tourist trails, others in quieter, less-commercialised retreats, where life moves at a slower pace and spiritual recuperation comes easy.

My earlier books on the Lake District were illustrated with black and white line drawings but this one has been my first opportunity to use colour to try and capture just a flavour of one of the most colourful areas of Britain. The notes provide some historical background and useful facts and figures. I've suggested a few easy low-level walks, which are intended as an introduction to the particular area, rather than presenting a physical challenge. Serious walkers are more than adequately served by a multitude of books and web pages.

If you're one of the eight million people a year who visit the Lake District, I hope this book will guide you to some of the places that have given me so much pleasure over the years. If you're one of the over 40,000 people who live within the National Park, count your blessings – you're **so** lucky!

Jim Watson

Rugby, 2010

An old oven in a wall at Hartsop (possibly to keep milk deliveries cool)

**Note:** All maps in this book are schematic and not drawn to scale.

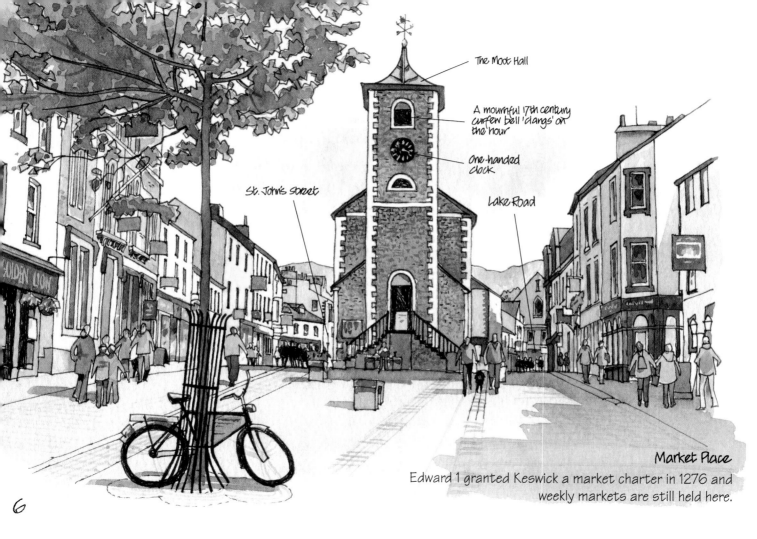

The Moot Hall

A mournful 17th century curfew bell 'clangs' on the hour

one-handed clock

St. John's street

Lake Road

Market Place

Edward 1 granted Keswick a market charter in 1276 and weekly markets are still held here.

6

George Fisher – World-famous climbing shop

DERWENT JEWELLERS LTD

A 'quiet' day in Lake Road

# KESWICK 'Queen of the Lakes'

The friendly old town is fabulously set between Derwent Water and Skiddaw with Borrowdale and the high mountains stretching seductively to the south.

Keswick developed with the 18th century mining industry and the world's first pencils were made here using graphite mined in Borrowdale. With the relocation of the pencil mill to Workington in 2008, Keswick is now totally given over to tourism. Traditional shops have been replaced by outdoor clothing stores (14 in Main Street alone at my last count!) gift shops or eateries.

The Moot Hall dates from 1813 and has seen service as a courthouse, prison, market, museum and town hall. Since 1971, the ground floor has been used as a National Park Information Bureau, the busiest in Lakeland with around 200,000 visitors a year.

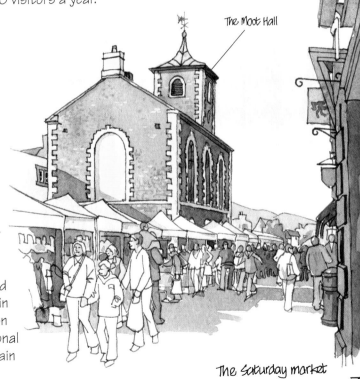

The Moot Hall

The Saturday market

7

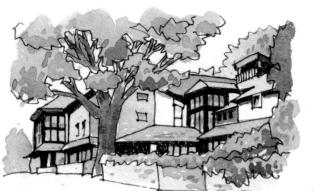

**Greta Bridge at High Hill.** The River Greta twists around the town before joining the Derwent as it flows out of Derwent Water then on through Bassenthwaite Lake to Cockermouth, where it contributed to the devastating floods of November 2009.

**The Theatre by the Lake.** Opened in 1999 replacing the old Blue Box Touring Theatre.

PARAFFIN ALLEY

So-called because the Keswick Restaurant in Market Square was once a hardware store which sold paraffin stored in a tank in the back alley.

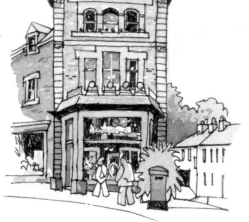

**Treeby & Bolton.** China shop, gallery and cafe in Lake Road.

**King's Head Court.** One of the many yards and alleys leading off Main Street.

8

A visit to Keswick is incomplete without a walk down Lake Road to Derwent Water. The view down the lake from the boat landings is one of the most popular in Lakeland. The Keswick launches have run a regular service calling at seven landing stages around the lake since 1904. Two boats, still in use, were built of Burma teak over 80 years ago and were originally for the exclusive use of Lodore Hotel residents. Car parking is frustrating around the lake and in Borrowdale, so combining a launch trip with a walk is one of the most relaxing ways to enjoy the area.

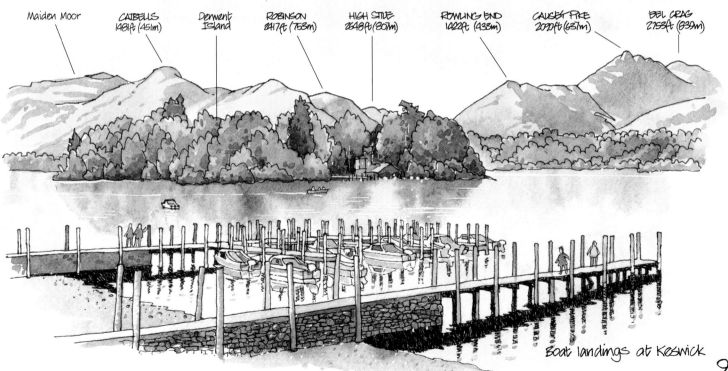

Maiden Moor

CATBELLS
1481ft (451m)

Derwent Island

ROBINSON
2417ft (753m)

HIGH STILE
2648ft (807m)

ROWLING END
1422ft (433m)

CAUSEY PIKE
2070ft (637m)

EEL CRAG
2753ft (839m)

Boat landings at Keswick

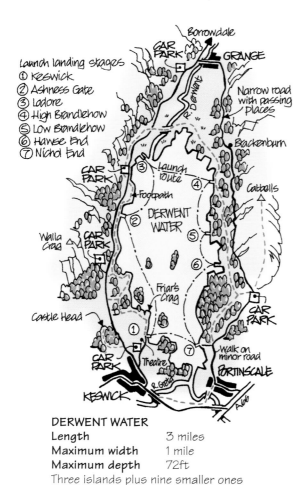

Launch landing stages
① Keswick
② Ashness Gate
③ Lodore
④ High Brandlehow
⑤ Low Brandlehow
⑥ Hawse End
⑦ Nichol End

Borrowdale
CAR PARK
GRANGE
Narrow road with passing places
R. Derwent
Brackenburn
CAR PARK
Launch route
Catbells
Footpath
DERWENT WATER
Walla Crag
CAR PARK
Friar's Crag
Castle Head
CAR PARK
Theatre
R. Greta
Walk on minor road
PORTINSCALE
KESWICK
A.66

**DERWENT WATER**

| | |
|---|---|
| Length | 3 miles |
| Maximum width | 1 mile |
| Maximum depth | 72ft |

Three islands plus nine smaller ones

# DERWENT WATER

Derwent Water has long being regarded as one of the most attractive of all the lakes. Couple it with Borrowdale and in this valley, more perfectly than anywhere else in the Lake District, are to be found the three components of the Romantic Ideal – rocks, trees and water – in glorious abundance. A splendid walk of about 10 miles goes all round the lake, with only the short stretch from Nickle End to Keswick being away from the lakeside.

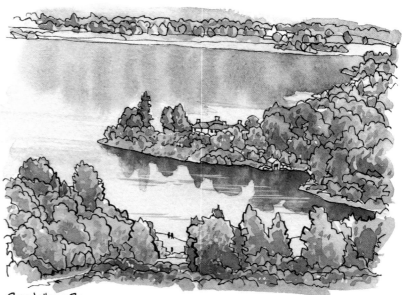

Brandelhow Bay

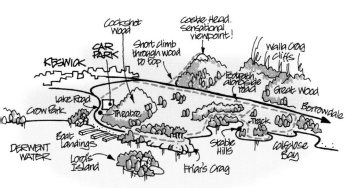

## A LAKESIDE WALK - WITH EXTRAS!

Go down Lake Road to Friar's Crag. Continue across a field on an obvious path into a small wood. When you come to a track turn right to skirt Stable Mills and follow the lakeside to Calf Close Bay. Head left to find the road back to Keswick and the footpath alongside it.

   Approaching the top of a long slope there are steps in the wall on the other side of the road into Castlehead Wood. A short climb takes you to the craggy top and a sensational view of Derwent Water and Borrowdale.

   Retrace your steps to the Keswick road. An enclosed path over a field leads to the Lake Road car park. A gentle walk of less than three miles but one packed with the very best of Lakeland.

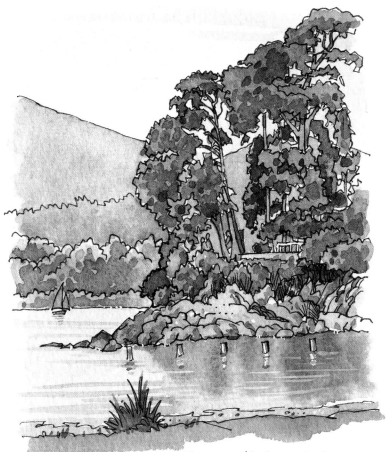

Friar's Crag - one of the most visited viewpoints in Lakeland

11

The art critic and social thinker, John Ruskin, put the view of Borrowdale from Friar's Crag in his top three in Europe, though he was prone to hyperbole. According to him Keswick was 'too beautiful to live in'. Nevertheless, the view is splendid – given clear conditions. Great End is nine miles away, so you could be peering through a lot of Lakeland mist.

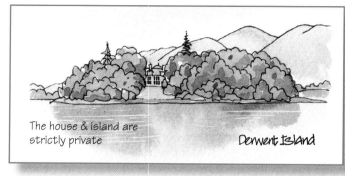

The house & island are strictly private

Derwent Island

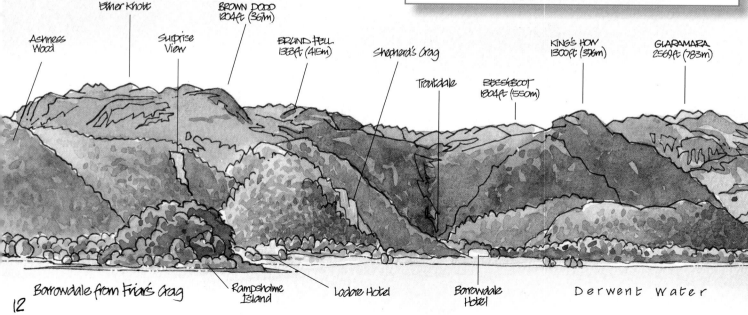

Ashness Wood

Ether Knott

Surprise View

BROWN DODD 1304ft (367m)

BRUND FELL 1363ft (415m)

Shepherd's Crag

Troutdale

BEESHBOOT 1304ft (550m)

KING'S HOW 1300ft (396m)

GLARAMARA 2569ft (783m)

Borrowdale from Friar's Crag

Rampsholme Island

Lodore Hotel

Borrowdale Hotel

Derwent Water

Derwent Island became a sanctuary for German miners in 1565 when they were badly received by the locals. In the 18th century the eccentric Joseph Pocklington built a house and various follies on the island. The Marshall family lived here for over a century, handing ownership to the National Trust in 1951.

Rampsholme Island once had a bloomery for smelting iron ore, while St Herbert's Island is named after the 7th century hermit immortalised by Wordsworth.

Derwent Water even has a 'ghost' island, rising from the lake bed on a cushion of marsh gas near Lodore. Believe it when you see it!

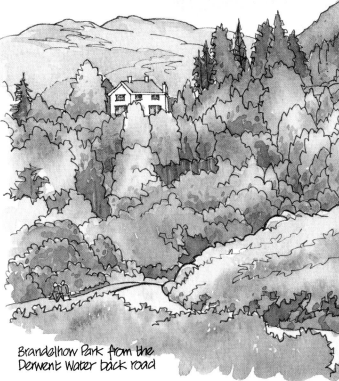

**Brandelhow Park from the Derwent Water back road**

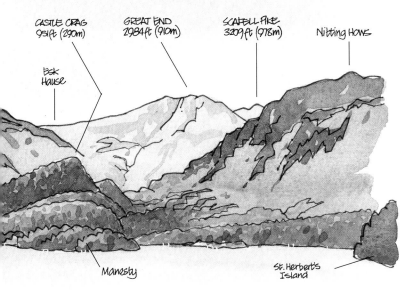

CASTLE CRAG 951ft (290m)
GREAT END 2984ft (910m)
SCAFELL PIKE 3209ft (978m)
Nitting Hows
Esk Hause
Manesty
St. Herbert's Island

The minor road between Portinscale and Grange is a scenic delight with sensational elevated views across the lake. However, the road is narrow with only passing places for oncoming traffic in parts. Unsurprisingly, it can be horrendously busy!

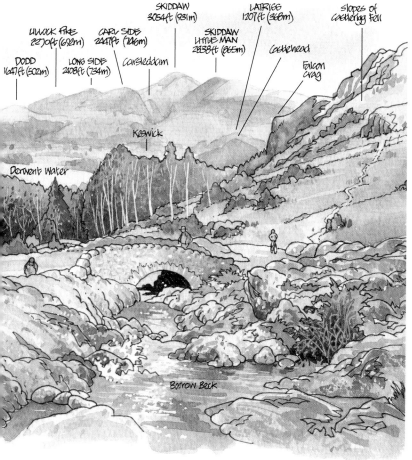

DODD
1647ft (502m)

LILLOCK FELL
2270ft (692m)

LONG SIDE
2408ft (734m)

CARL SIDE
2447ft (746m)

Carsleddam

SKIDDAW
3054ft (931m)

SKIDDAW
LITTLE MAN
2838ft (865m)

LATRIGG
1207ft (368m)

Castlehead

Falcon
Crag

slopes of
Castlerigg Fell

Keswick

Derwent Water

Barrow Beck

Ashness Bridge - THE photographer's favourite

14

## ASHNESS & WATENDLATH

The hamlet of Watendlath nestles at the head of a Lake District 'hanging valley', 600ft above the surface of Derwent Water. The tiny tarn, pack horse bridge and a huddle of farm buildings is one of the most photographed compositions in Lakeland. Hugh Walpole, who lived across the lake at Brackenburn and is buried in St John's churchyard, Keswick, set his 'Herris Chronicle' books here.

Furness Abbey records mention Watendlath as part of their estate in 1209. The area is now owned by the National Trust which resists unsuitable development and ensures that traditional sheep farming is still carried on.

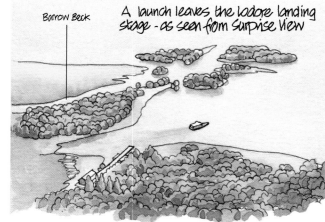

Barrow Beck

A launch leaves the Lodore landing stage - as seen from Surprise View

You can drive to Watendlath along a narrow road with passing places, but that is to miss one of the greatest pleasures of a visit – the walk there.

Much better to take the launch from Keswick to Ashness Gate and walk up the steep lane to Ashness Bridge and through the wood to Surprise View, both superlative viewpoints. Continue to the end of the wood, then turn right to cross the beck and take the beckside path to Watendlath. Four miles that can touch you for life.

Watendlath Beck has a short but spectacular journey to Derwent Water – down Lodore Falls, a 90ft series of cascades through a wooded gorge. Well worth a look after rain. Access is from behind the Lodore Hotel.

Watendlath has a pay car park, toilets and a small tea garden which usually closes during the winter.

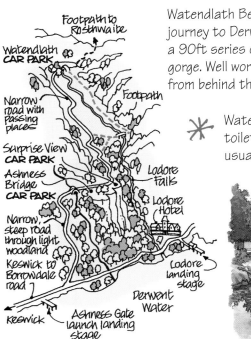

Footpath to Rosthwaite
Watendlath CAR PARK
Narrow road with passing places
Footpath
Surprise View CAR PARK
Ashness Bridge CAR PARK
Lodore Falls
Lodore Hotel
Narrow, steep road through light woodland
Keswick to Borrowdale road
Lodore landing stage
Derwent Water
Keswick
Ashness Gate launch landing stage

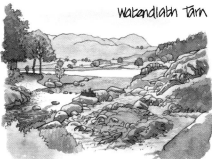

Watendlath Tarn

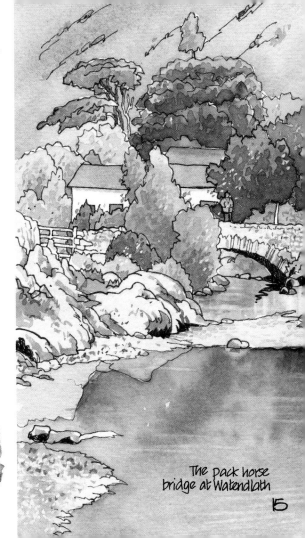

The pack horse bridge at Watendlath

15

# GRANGE

Established by Furness Abbey in the 14th century to administer its local affairs, Grange straddles Borrowdale where the valley narrows forming the aptly-named 'Jaws of Borrowdale'. The River Derwent widens as it passes the village and a bridge, built in 1675, requires two graceful arches to cross. The water in the river is remarkably clear, setting off the colours of stones which have been worn smooth by the passage of copious quantities of water.

Slate-built and genteel, modern Grange marks its ecclesiastical past by having both a chapel and a church, and continues to look after local affairs by catering for the needs of the multitudes of tourists who pass along its narrow streets. Parking is well-nigh impossible.

the Bowder Stone.

A 2,000-ton Victorian curiosity situated in woodland at the foot of King's How.

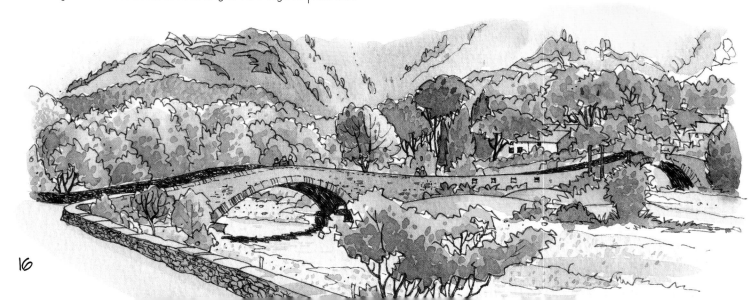

# ROSTHWAITE

Beyond Grange, Borrowdale widens to farmland. At the centre stands Rosthwaite, raised above the flood plain of the Derwent on a rocky knoll. A passing motorist might see the hamlet as no more than an irritating bottleneck, but away from the main road this is a place of infinite nooks and crannies, whitewashed cottages and comfy lodging places. There's even a village Post Office and a car park – which fills remarkably quickly.

Yew Tree Farm

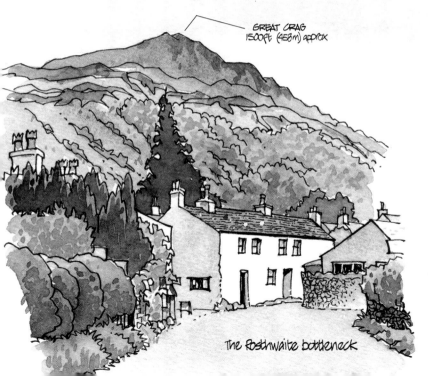

GREAT CRAG
1500ft (458m) approx

The Rosthwaite bottleneck

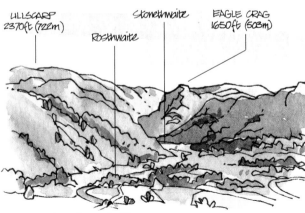

ULLSCARP
2370ft (722m)

Rosthwaite

Stonethwaite

EAGLE CRAG
1650ft (503m)

Borrowdale from Castle Crag

# CASTLE CRAG

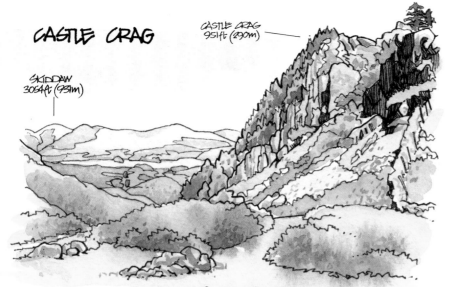

SKIDDAW
3054ft (931m)

CASTLE CRAG
951ft (290m)

Castle Crag and Derwent Water from the Rosthwaite Path

Castle Crag has no castle, is of lowly elevation and scarred by extensive quarrying – a rotten tooth in the Jaws of Borrowdale. Yet, now richly wooded, nature has turned the abrupt, rocky pyramid into a romantic and independent Lakeland talisman. It's also a fantastic viewpoint.

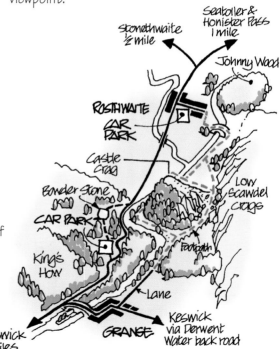

Stonethwaite ½ mile

Seatoller & Honister Pass 1 mile

Johnny Wood

ROSTHWAITE CAR PARK

Castle Crag

Low Scawdel Crags

Bowder Stone

CAR PARK

King's How

Footpath

Lane

Keswick 4 miles

GRANGE

Keswick via Derwent Water back road

'Containing no high mountain, no lake, no famous crag, no tarn, but in the author's humble submission, it contains the loveliest square mile in Lakeland – the Jaws of Borrowdale.'

Alfred Wainwright describing the area around Castle Crag in Book Six of his *Pictorial Guide to the Lakeland Fells*.

In the same book he also wrote:

'If a visitor has only two or three hours to spare... yet desperately wants to take back an enduring memory of the district, let him climb Castle Crag.'

Amen to all that!

18

A circular walk of no more than three miles takes in most of Wainwright's 'loveliest square mile'.

Cross the pack horse bridge over the Derwent out of Rosthwaite and take the obvious path to Castle Crag. The ascent, up a slate spoil heap, looks daunting but is perfectly safe. The grassy top has long falls on all sides, so take care.

Descend the crag and go through the wood to the riverside. Take the lane on the left to visit Grange. Retrace your steps and follow the river around the base of Castle Crag back to Rosthwaite.

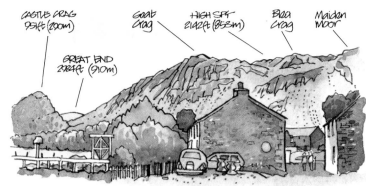

The view south from Grange

The view north from Castle Crag summit

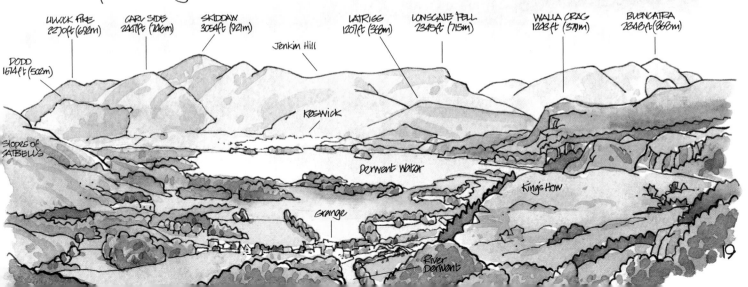

19

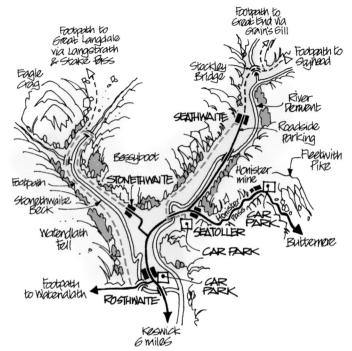

## STONETHWAITE

Only a couple of miles long but, Stonethwaite, a tranquil side valley off Borrowdale, has all the attributes of classic Lakeland: wooded slopes, fearsome crags, a lively beck and one of the prettiest hamlets in the district.

The narrow road dwindles out at a campsite and the rest of the valley is left to walkers, some who will climb up Langstrath and cross Stake Pass into Great Langdale. Others take Greenup Gill to the left of Eagle Crag and go over to Grasmere.

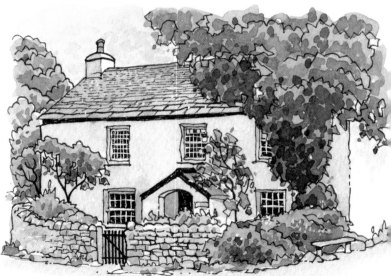

*A classic lakeland cottage at Stonethwaite*

In medieval times most of Borrowdale belonged to the mighty Furness Abbey but Watendlath, Longstrath and Seathwaite were owned by the equally important Fountains Abbey in Yorkshire. With two large landowners rubbing shoulders there were the inevitable disputes.

The view back to Borrowdale

A circular walk of around four miles up one side of Stonethwaite Beck and down the other is an excellent introduction to the wild and wonderful topography of the valley.

From Rosthwaite walk south along the narrow main road. At the first junction turn left to pass the pretty Borrowdale church and further on the even prettier hamlet of Stonethwaite itself. The great buttress of Bull Crag towers above as the way ahead becomes more open.

Beyond a beckside campsite the route swings right, into the wilds of Langstrath. Find a footbridge and cross the beck.

The return to Rosthwaite is on a well-trodden part of the Cumbria Way with some great fell views. It also passes some delectable – and cold! – bathing pools in the beck.

The view up Langstrath

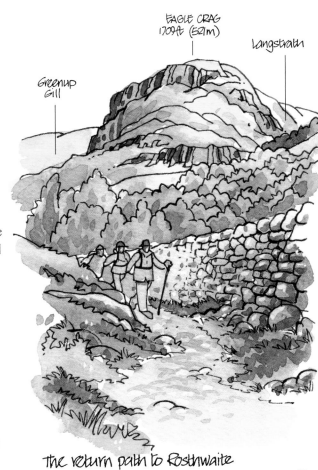

The return path to Rosthwaite

21

# SEATHWAITE

The most southerly point of the long Borrowdale valley and a settlement of only a few farm buildings, but Seathwaite is nationally famous as the wettest inhabited place in England. It's also well-known and well-loved by fellwalkers – to whom wet weather is frequently a way of life – as the gateway to Paradise, the great fells of Lakeland. Popular routes to Scafell Pike, Great Gable and Glaramara begin and end here. On a fine summer's day – it does happen – Seathwaite can seem like Piccadilly Circus.

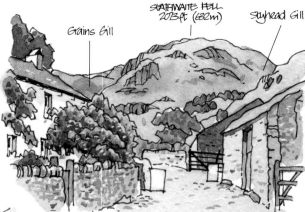

Seathwaite Farm

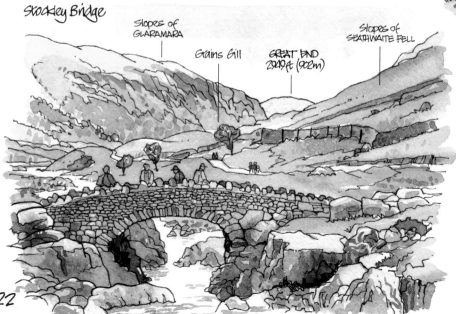

Stockley Bridge

Around 140in of rain falls on Seathwaite in an average year. In September 1966, five inches of rain fell in one hour. The resulting flood swept away nearby Stockley Bridge, which has since been rebuilt in its original packhorse bridge style.

Records were shattered in November 2009 when 19.29in of rain fell on Seathwaite in four days, roughly equivalent to ten months average rainfall in London. At Sprinkling Tarn, on the fells above Seathwaite, it's even wetter, measuring a prodigious average of 172.9in a year.

Seatoller

The hamlet of Seatoller at the foot of Honister Pass has facilities and a car park, so is a good base for walkers. A low-level route of about four miles goes up the minor road to Seathwaite and returns along the other side of the valley on a well-established footpath, part of the Allerdale Ramble.

Look out for the waterfall of Sour Milk Gill above Seathwaite and nearby, on Base Brown, the remains of 16th century plumbago (or graphite) mines which established the Keswick pencil industry. At one time plumbago was so valuable it could only be transported under armed guard. The yield gradually diminished and the last Seathwaite mine closed in 1836.

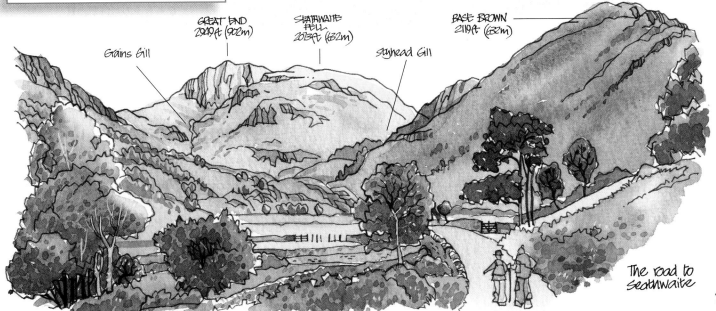

GREAT END
2949ft (902m)

Grains Gill

SEATHWAITE FELL
2073ft (632m)

Styhead Gill

BASE BROWN
2119ft (632m)

The road to Seathwaite

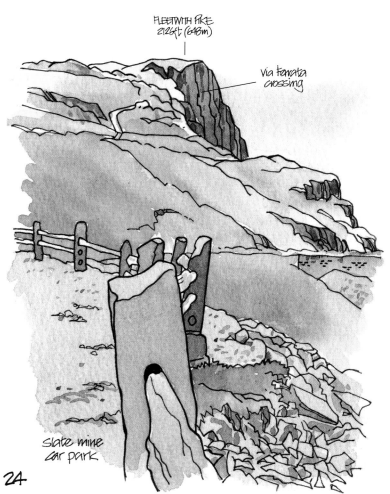

FLEETWITH PIKE
2126ft (648m)

via ferrata
crossing

slate mine
car park

# HONISTER PASS

The only exit from upper Borrowdale for motorists is the climb over Honister Pass into Buttermere. With gradients of one in four and an altitude of 1,167ft, it's one of the steepest and highest in the region.

Remarkably, there was once a regular stagecoach service over the pass. It began in the 1860s and only ended when the road was properly surfaced in 1934 and the horses' hooves could not grip on the tarmac.

The characteristic light green slate seen in local walls, on rooftops and in more highly-polished form as coffee table tops or in gift shops has been mined at Honister since the late 1600s. By 1890 production had reached 3,000 tons a year and more than 100 men were employed. In those days the mine was so isolated messages to the company offices in Keswick were sent by carrier pigeon.

But the business gradually declined and in the 1980s there was a possibility of a complete shutdown. However, in 1997 the mine was reopened by new owners, Bill Taylor and Mark Weir, as a tourist attraction. With some inspired entrepreneurship, including mine tours and a hairy (but safe) Via Ferrata crossing of the Fleetwith Pike rockface high above Honister Pass, the good times have come to Honister. Slate is back in commercial production and Mark Weir even commutes to work in his own helicopter!

The treeless but grassy summit plateau of Honister Pass is an excellent place to picnic, with a terrific view across Borrowdale to the Helvellyn range. It's also a good starting point for a number of fell walks: Fleetwith Pike, Dalehead and the 'easy way' up Great Gable.

The Buttermere side is more rugged than the Borrowdale one and Gatesgarthdale Beck bubbles most attractively down to Buttermere.

Lookout for sheep on the roads. They roam freely throughout this unfenced area.

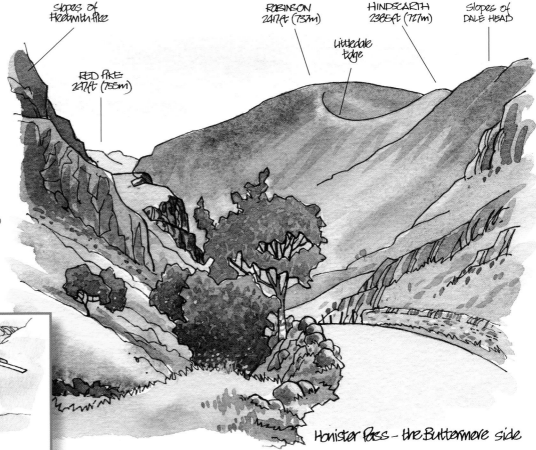

Slopes of Fleetwith Pike

RED PIKE 2417ft (755m)

ROBINSON 2417ft (737m)

HINDSCARTH 2385ft (727m)

Slopes of DALE HEAD

Littledale Edge

The mine owner's helipark

Honister Pass - the Buttermere side

25

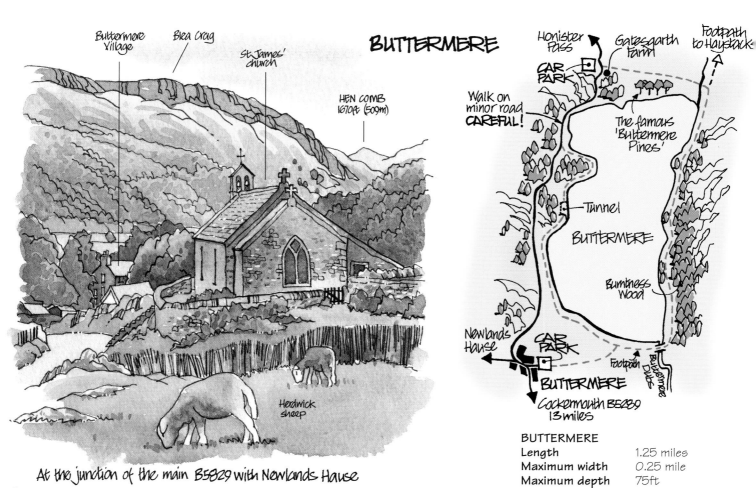

Buttermere Village  Blea Crag  St James' church

HEN COMB
1670ft (509m)

Herdwick
sheep

At the junction of the main B5289 with Newlands Hause

26

# BUTTERMERE

Honister Pass  Gatesgarth Farm  Footpath to Haystacks

CAR PARK

Walk on minor road CAREFUL!

The famous 'Buttermere Pines'

Tunnel

BUTTERMERE

Burtness Wood

Newlands Hause

CAR PARK

Footpath  Buttermere Dubs

BUTTERMERE

Cockermouth B5289 13 miles

BUTTERMERE
Length            1.25 miles
Maximum width     0.25 mile
Maximum depth     75ft

The eight miles long Buttermere valley runs north-west from high ground around Great Gable down to the flat meadows of Lorton. There are three lakes – Buttermere, Crummock Water and, just off the main valley, Loweswater – strung together like jewels on a necklace. The little village of Buttermere lies between the two southermost lakes.

The scenery is spectacular with the rugged 2,000ft (610m) high ramparts of the High Stile range an omnipresence across the lake. The view of the valley is justifiably famous and one of the lower but shapely fells, Haystacks, achieved even greater prominence in 1991 when the ashes of one of its greatest admirers, the fellwalker, Alfred Wainwright, were scattered across its craggy summit.

A popular family walk goes all the way round the lake starting from the Buttermere or Gatesgarth car parks. Part of the route goes through a tunnel dug by gardeners at nearby Hassness House to alledgedly give them something to do during the winter.

Buttermere village is well geared up for visitors but predictably the car park, and the one at Gatesgarth, fill up quickly.

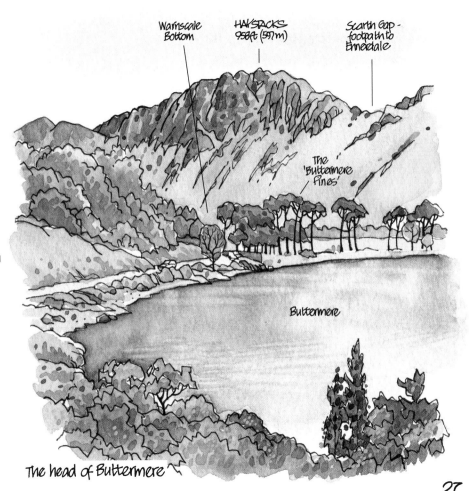

Warnscale Bottom

HAYSTACKS 958ft (597m)

Scarth Gap - footpath to Ennerdale

The 'Buttermere Pines'

Buttermere

The head of Buttermere

27

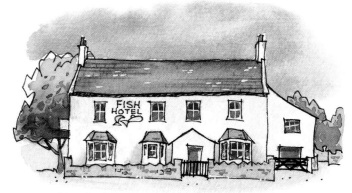

## The Fish (Inn) Hotel

The tabloids of the time went into overdrive in 1802 when Mary Robinson, the daughter of the landlord of the Fish Inn (now 'hotel'), was tricked into marriage by a dastardly conman and bigamist calling himself the Honourable Alexander Hope. He was unmasked by the local gentry, tried for franking his mail as a bogus MP and hanged at Carlisle a year later.

Mary, 'The Maid of Buttermere', had plays and songs written about her – even Wordsworth mentioned the scandal in his *Prelude* – and visitors flocked to the Fish to catch a glimpse of the unfortunate girl. More recently, in 1987, Melvyn Bragg wrote a novel based on her story.

Mary later married a Caldbeck farmer, led a relatively contented life raising four children and died in 1837.

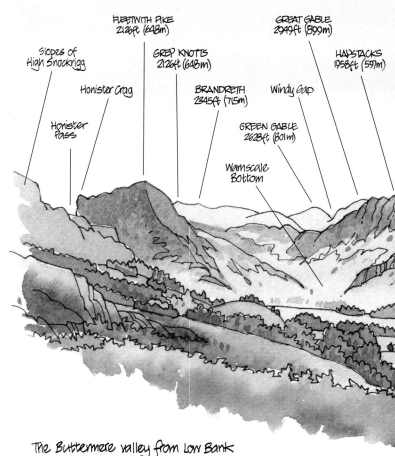

The Buttermere valley from Low Bank

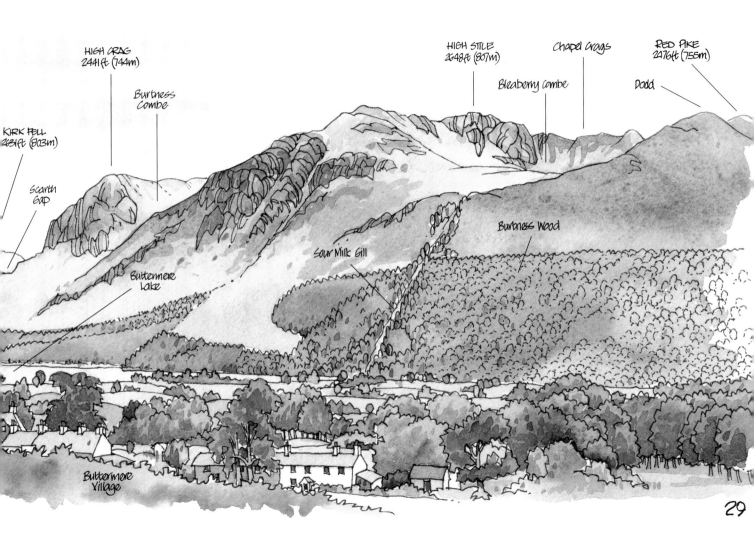

KIRK FELL
2631ft (803m)

Scarth
Gap

HIGH CRAG
2441ft (744m)

Burtness
Combe

Buttermere
Lake

Sour Milk Gill

HIGH STILE
2648ft (807m)

Bleaberry Combe

Chapel Crags

RED PIKE
2476ft (755m)

Dodd

Burtness Wood

Buttermere
Village

29

# NEWLANDS

Newlands Hause climbs steeply out of Buttermere on a minor road and descends gradually through the valley of Newlands. You can stop at the top of the hause to admire the view and a waterfall. For many years, Newlands was a hive of mining industry but now — and considering how close it is to major tourist centres — it's a surprisingly tranquil and unspoilt gem. There are little roads around the dale but they go nowhere in particular, which all adds to the attraction. Little Town is said to be the inspiration for Beatrix Potter's. *The Tale of Mrs. Tiggy Winkle.*

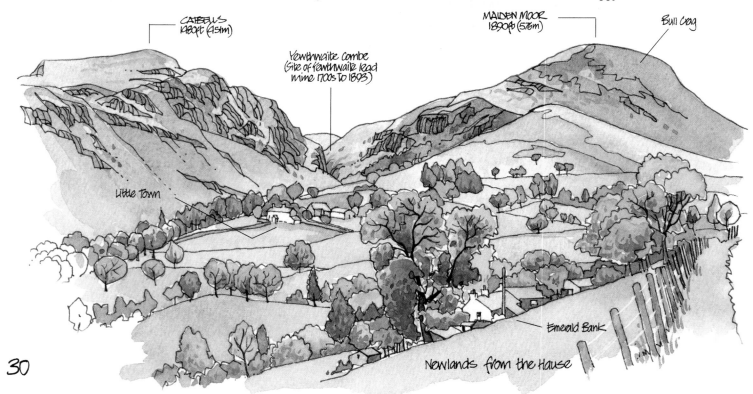

CATBELLS
1481ft (451m)

MAIDEN MOOR
1890ft (576m)

Bull Crag

Yewthwaite Combe
(Site of Yewthwaite Road
mine 1700s to 1893)

Little Town

Emerald Bank

Newlands from the Hause

# ST JOHN'S IN THE VALE

Another peaceful haven is the seven miles of the B5322 along St John's in the Vale, linking two of the busiest roads in the area; the A66 at Threlkeld and the A591, the main arterial route through the Lake District at Thirlspot. The dramatic south face of Blencathra dominates the view to the north.

I lived at Threlkeld during my formative years and spent a lot of time dissipating my teenage angst by exploring the soaring ridges and deep gullies of this magnificent mountain. Whenever I travel north on the A591 these days the first sight of my old friend along St John's is always a emotional moment.

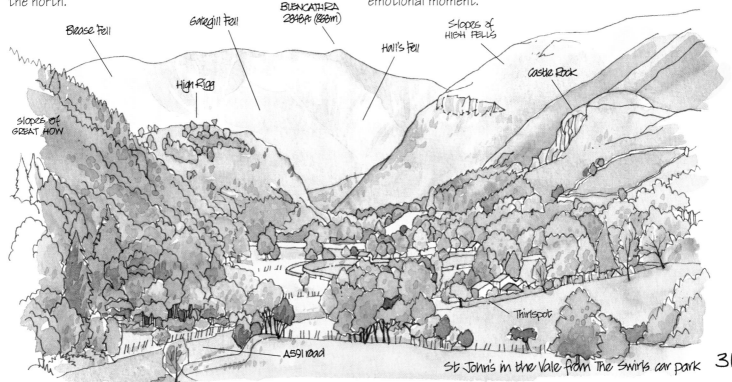

Blease Fell

Gategill Fell

BLENCATHRA 2848ft (868m)

Hall's Fell

Slopes of HIGH FELLS

High Rigg

Castle Rock

Slopes of GREAT HOW

Thirlspot

A591 road

St John's in the Vale from The Swirls car park

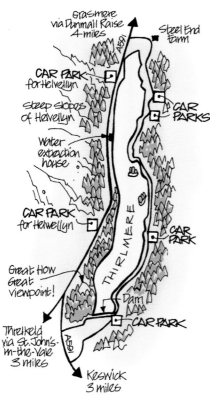

# THIRLMERE

Though often overlooked in the pantheon of Lakeland picturesque on the grounds that it was created by human endeavor and thus 'unnatural', Thirlmere is worth attention as the only significant stretch of water with the mighty Helvellyn range as a backdrop. It's also a superb example of Victorian civil engineering.

The fellsides around the lake were originally planted with 120 acres on conifers as an early cash crop, but the alien trees were widely disliked. Thanks to modern forestry management, Thirlmere now has a more natural look and it's a pleasant area to visit for a walk by the lake or through the woods.

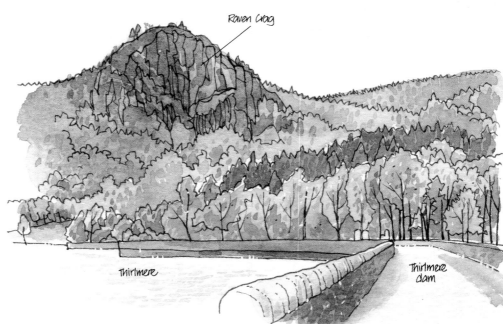

**THIRLMERE**

| | |
|---|---|
| Length | 3.75 miles |
| Maximum width | 0.75 miles |
| Maximum depth | 131ft |
| Two islands, both private | |

Thirlmere was created from two smaller lakes – Leathes Water and Wythburn Water – by the construction of a dam during 1890-94 to supply water to the city of Manchester via a 100-mile long aqueduct.

With the basic pipeline established in 1897 and subsequent phases completed in 1925, the Thirlmere Aqueduct is the longest gravity-fed aqueduct in the country with no pumps anywhere along its route. A tunneled section was dug under Dunmail Raise by two teams working towards each other. The two tunnels met within 10in of centre.

Situated at the north end of the lake, the dam raised the lake level by 50ft. It's 857ft long and 50ft thick at the bottom, rising 64ft above the old stream bed. There's a road across the 18ft wide top. An outlet flows north down St John's Beck, joining the Gleneramackin at Threlkeld to become the Greta which flows through Keswick.

The A591 borders the eastern shore and the narrow original valley road goes along the west. There are car parks at Thirlspot and Wythburn but nowhere else to stop on the A591. The old road has car parks along the lakeside. Apart from the King's Head, a 17th century coaching inn at Thirlspot, the area has no other facilities.

The view north from Hause Point

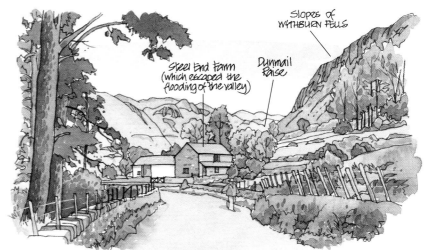

The old road at the south end of the lake

33

# GRASMERE

The best-known, most visited, and most revered of all the Lakeland villages, Grasmere sits regally in a lush bowl of fells, overlooked in the north by Helm Crag and edged by the pretty lake in the south which shares the village name. A grey slate collection of hotels, gift shops and cafes, Grasmere is never going to rival its surroundings in a beauty contest but it is a pleasant enough tourist honeypot. The River Rothay meanders around the village and an inspired footpath follows it linking two car parks, one at each end of the village.

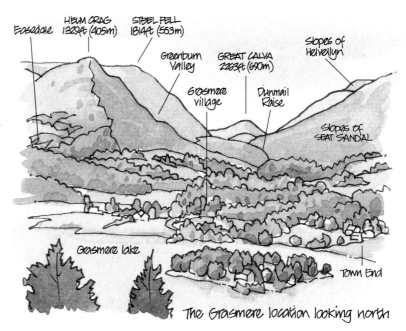

Easedale
HELM CRAG 1329ft (405m)
STEEL FELL 1814ft (553m)
Greenburn Valley
GREAT CALVA 2263ft (690m)
Slopes of Helvellyn
Grasmere village
Dunmail Raise
Slopes of SEAT SANDAL
Grasmere lake
Town End

The Grasmere location looking north

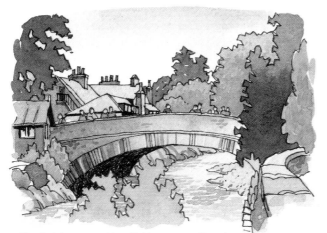

The bridge over the Rothay near the church

The romantic popularisation of Grasmere began with the Lake Poets and particularly with the village's most famous literary lion, William Wordsworth. He was a true Cumbrian, born at Cockermouth in 1770, schooled at Hawkshead and resident of the Rothay valley in various houses for over 50 years until his death in 1850.

The Wordsworth Museum at Town End draws tourists and serious scholars from all over the world and the £3m Wordsworth Trust Research Centre dedicated to the study of Wordsworth and British Romanticism opened nearby in 2005.

# THE WORDSWORTH HOUSES

William Wordsworth and his sister, Dorothy moved into Dove Cottage, a former inn, in 1799. He married Mary Hutchinson in 1802, a childhood friend who bore him five children. After a happy, if cramped, eight years they relocated to Allan Bank, a large house on the lower slopes of Helm Crag. But William worried about the extra expense, so two years later they moved to the rectory in the village. Here two of the Wordsworth children died. Mortified, William left Grasmere in 1813 to spend the rest of his life as a country gent, two miles away at Rydal Mount. He died there, aged 80, in 1850.

Grasmere Rectory (1811-15)

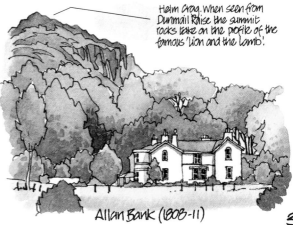

Helm Crag. When seen from Dunmail Raise the summit rocks take on the profile of the famous 'Lion and the Lamb'.

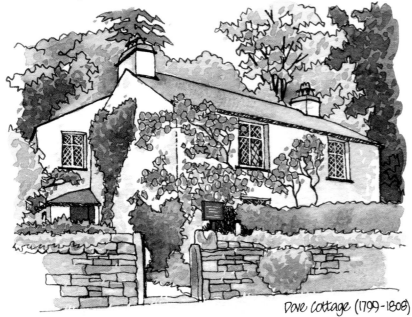

Dove Cottage (1799-1808)

Allan Bank (1808-11)

35

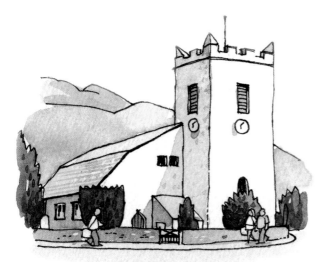

St. Oswald's church and the Langdale entrance

Various water-proofing methods over the years have given the external walls of St Oswald's church a grey and sombre look but inside it's surprisingly bright and beautiful. The earliest parts of the building date back to the 13th century and the lower walls are four feet thick.

The early church had an earthen floor covered with rushes from the lakeside which, until 1841 when the floor was flagged, were renewed at least once a year, The custom survives in the annual Rush Bearing Ceremony held on the nearest Saturday to St Oswald's Day, August 5th. The Wordsworths were regular worshippers at St Oswald's and fifteen of the extended family are buried in the churchyard.

St Oswald's church was the parish church for Grasmere, Rydal and Langdale, with each township having its own entrance to the churchyard.

The Gingerbread Shop is part of the old Grasmere entrance and used to be the village schoolroom, built in 1882. In 1854, the room was let to Sarah Nelson, who first made the hard and spicy Grasmere Gingerbread here. The business continues to this day but the recipe remains a closely guarded secret.

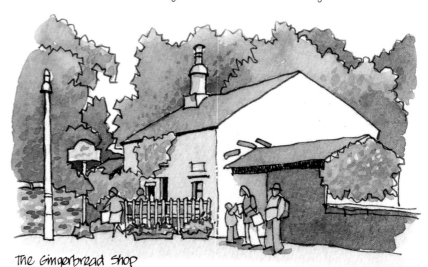

The Gingerbread Shop

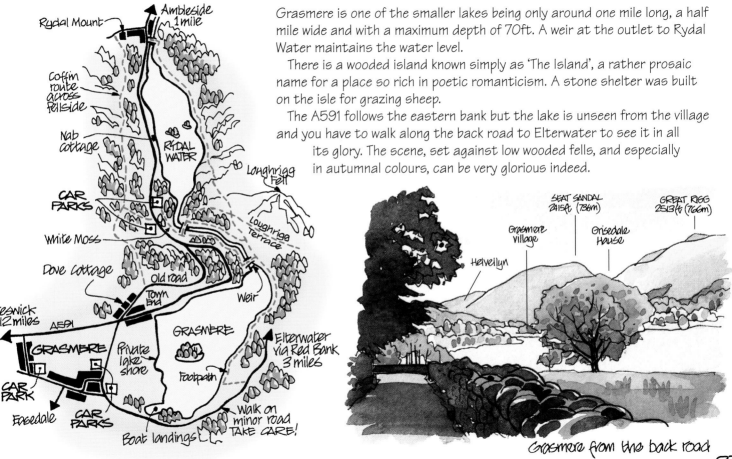

Rydal Mount

Ambleside
1 mile

Coffin route across Fellside

Nab cottage

RYDAL WATER

Loughrigg Fell

Loughrigg Terrace

CAR PARKS

White Moss

Dove Cottage

Old road

Town End

Weir

Keswick 12 miles

A591

GRASMERE

GRASMERE

Private lake shore

Footpath

Elterwater via Red Bank 3 miles

CAR PARK

Easedale

CAR PARKS

Boat landings

Walk on minor road TAKE CARE!

Grasmere is one of the smaller lakes being only around one mile long, a half mile wide and with a maximum depth of 70ft. A weir at the outlet to Rydal Water maintains the water level.

There is a wooded island known simply as 'The Island', a rather prosaic name for a place so rich in poetic romanticism. A stone shelter was built on the isle for grazing sheep.

The A591 follows the eastern bank but the lake is unseen from the village and you have to walk along the back road to Elterwater to see it in all its glory. The scene, set against low wooded fells, and especially in autumnal colours, can be very glorious indeed.

SEAT SANDAL 2415ft (736m)

GREAT RIGG 2513ft (766m)

Grasmere village

Grisedale House

Helvellyn

Grasmere from the back road

37

# A WALK AROUND THE ROTHAY VALLEY

It's possible to walk all the way round Grasmere although only about half of it has public access to the lakeshore. Better to include neighbouring Rydal Water for a grand tour of about six miles.

Beginning at Grasmere village walk along the back road towards Elterwater. After about a mile a pathway goes down to the lakeside and an obvious path to a stoney beach where the River Rothay flows out of Grasmere. A short climb up the lower slope of Loughrigg Fell brings Rydal Water into view. The wooded area between the two lakes is White Moss, a popular parking and leisure area.

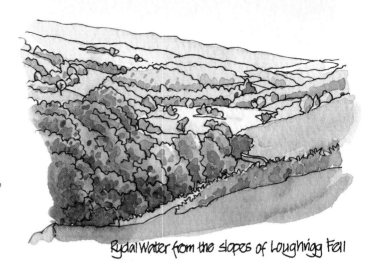

Rydal Water from the slopes of Loughrigg Fell

Rydal Water is 1,290ft long with a maximum width of 380yd and a maximum depth of 65ft. Almost surrounded by fells and with only one building in sight, Nab Cottage, the lake has a look of remoteness quite contrary to its actual location, less than a mile out of busy Ambleside.

The lakeside path ends at a footbridge over the Rothay into the hamlet of Rydal, which would be fairly ordinary if it wasn't for the legacy of Wordsworth. The route climbs up the steep lane to Rydal Mount and turns left just past the house onto a path across the lightly wooded hillside. This was the coffin route to Grasmere before the church was built at Rydal. There's terrific elevated views across Rydal Water and Grasmere for two miles before descending past Dove Cottage back into Grasmere village.

Rydal Water from the old coffin route

# RYDAL

Wordsworth never owned his own home but managed to live rather grandly at Rydal Mount for the last 37 years of his life. However, a descendant of the poet subsequently bought Rydal Mount and it has been open to the public since 1970.

William helped to establish – and design – St Mary's church at Rydal, finished in 1824. He bought the field next to the church for his daughter. Bright with a host of dancing daffodils every spring, it's still known as Dora's Field. After she died in 1847 Wordsworth never wrote another line of poetry.

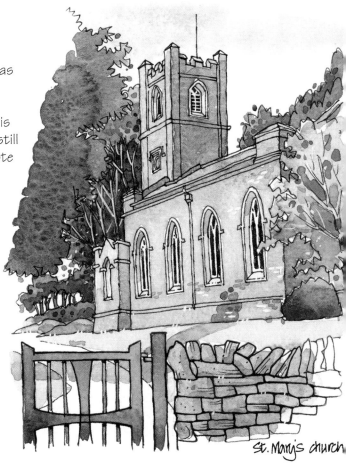

St. Mary's church

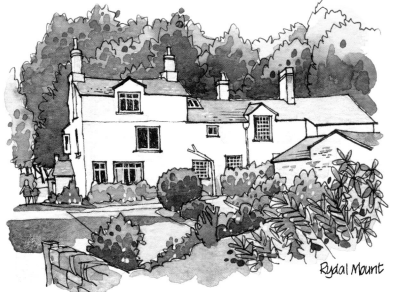

Rydal Mount

39

# AMBLESIDE

A bustling town of shops, hotels, guest houses, pubs and restaurants, and superbly set between the head of Windermere and a panorama of shapely fells, Ambleside is the perfect base for exploring central Lakeland. There's everything the visitor needs – except probably somewhere to park. Best to park on the outskirts and walk into town.

Ambleside has long been a popular stopping place for travellers. At the end of the 17th century it had five ale houses and a weekly market. The coming of the railway in the mid-18th century – even though it only came as far as Windermere – opened up the area to a huge influx of visitors. Ambleside's first outdoor shop opened in 1959 and they seem to have never stopped opening since.

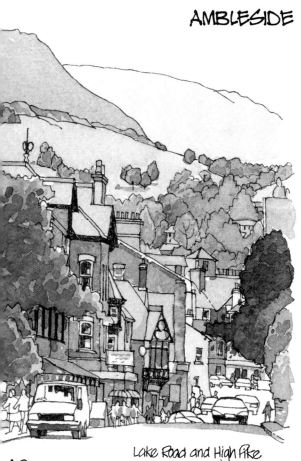

Lake Road and High Pike

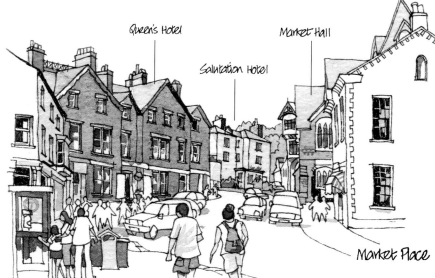

Queen's Hotel

Salutation Hotel

Market Hall

Market Place

40

Walking and climbing are now a vital part of the local economy. Apart from being able to amply supply all the necessary equipment, Ambleside, with fells on three sides and a lake on the other, is one of the best places to put it to use. A walk up 55 steps from Lake Road will take you to Lower Gale from where the glorious backdrop of fells around the town can be appreciated without a huge amount of effort.

A Victorian 'cocktail belt' extended between Ambleside and Grasmere. Apart from the resident Lake Poets there was a constant procession of the country's intellectual glitterati, many of whom had second homes in the area.

Wordsworth had an odd connection with Ambleside. Soon after he moved to Rydal Mount he became Collector of Stamps for Westmorland, a government position which involved the distribution of stamps required on all official documents and the collection of fees. His office was in Church Street, Ambleside. It was the only 'proper job' that Wordsworth ever did.

The Stamp House

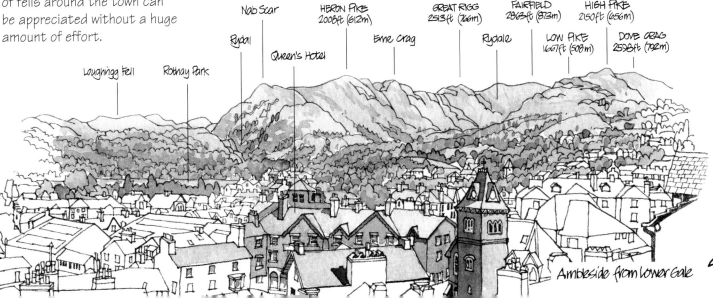

Ambleside from Lower Gale

41

Stock Beck once drove five water mills. One, originally a bark crushing mill for making tannin used in the leather trade, has been converted to cottages and flats. Another, once a corn mill, boasts a replica overshot waterwheel.

Stockghyll Force, a spectacular 70ft waterfall plunging in twin ribbons to a rocky basin, is a short walk upstream.

Ambleside's most iconic building, Bridge House, spans Stock Beck and has survived not only megastardom on calendars and postcards, and as a pottery ornament, but also the construction of Rothay Road in 1833. Built as an apple store for nearby Ambleside Hall, it's now a rather cramped National Trust Shop. The roof still has the original 17th century 'wrestler' slates along the ridge.

Ash Tree Cottage

The best-looking part of Ambleside is the old village on Smithy Brow, the lower but steep slopes of Kirkstone Pass. There are some superb examples of 16th and 17th century vernacular architecture, with their characteristic huge chimneys, small windows and local stone walls.

Windermere lake ends a mile short of Ambleside which may come as a surprise to many of the day-trippers who leave the ferries from Bowness expecting to be in the town. Waterhead does its best with a huddle of tourist shops but the view across the water, crowded with ducks and boats, to the distant Langdale Pikes, beats everything.

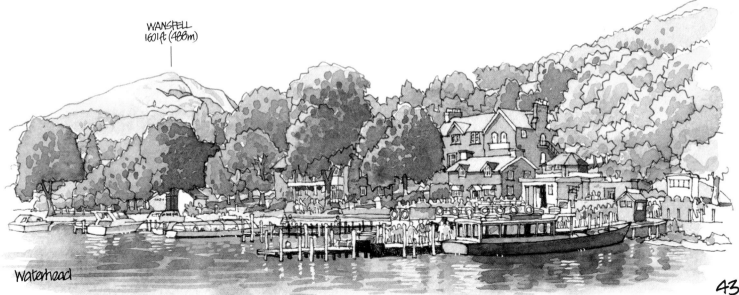

WANSFELL
1601ft (488m)

Waterhead

43

# ELTERWATER

Sitting serenely at the entrance to Great Langdale, the picturesque village of Elterwater has an industrial history totally at odds with today's tranquil character. The cluster of cottages, built of green slate from nearby quarries, gather around one of the prettiest village greens in Lakeland with the 17th century Britannia Inn at its head and a magnificent maple tree shading a circular wooden seat.

Elterwater is now totally tourism based with, it's said, only a quarter of the houses being permanently occupied. The rest are holiday homes.

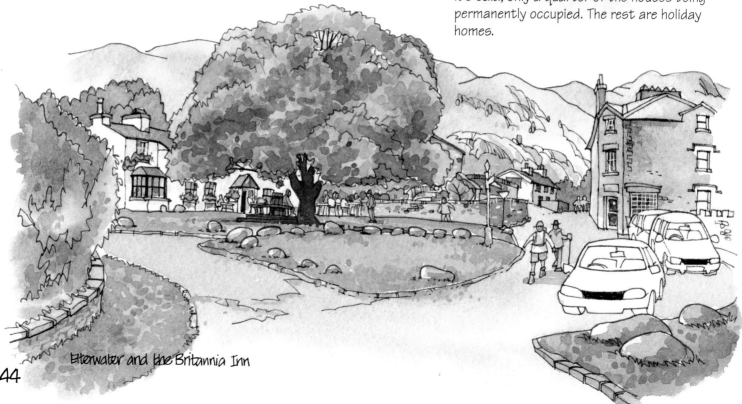

Elterwater and the Britannia Inn

Slate quarrying was well established in the area by the end of the 18th century. In 1824, the quarry owners converted an old bark mill in the village into a gunpowder factory. Local juniper wood was used in the manufacturing process. Eighteen waterwheels provided power and up to 90 people were employed. A cannon was regularly fired to test the product.

When demand dwindled the works were closed in 1920 and the buildings demolished. The site was opened as a time share estate in 1981. Quarrying is still carried on in the hills behind the village.

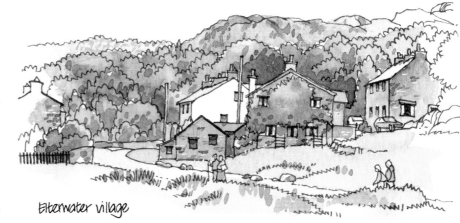

Elterwater village

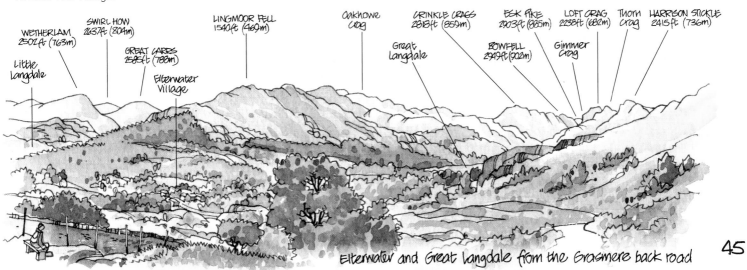

WETHERLAM 2502ft (763m)

Little Langdale

SWIRL HOW 2637ft (804m)

GREAT CARRS 2585ft (788m)

Elterwater Village

LINGMOOR FELL 1540ft (469m)

Oakhowe Crag

Great Langdale

CRINKLE CRAGS 2818ft (859m)

BOWFELL 2949ft (902m)

ESK PIKE 2903ft (885m)

Gimmer Crag

LOFT CRAG 2238ft (682m)

Thorn Crag

HARRISON STICKLE 2415ft (736m)

Elterwater and Great Langdale from the Grasmere back road

Former quarryworkers' cottages

The early Norse settlers in the valley called Elterwater *Elpt Vatn* (Swan Lake) after the whooper swans which are still notable winter migrants from Siberia.

Much of the lowland around Elterwater was once swamp until it was bought up by an enterprising man, John Harden, in 1820. He deepened the lake and drained the marches, creating the landscape of bumps and hillocks seen today. In the 1830s he sold back the reclaimed land to local farmers. At a handsome profit, no doubt.

✳ Popular Lakeland artist, Judy Boyes, has a gallery near the green in the village which is well-worth a visit.

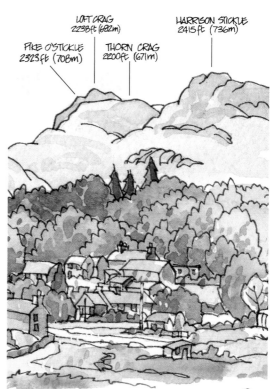

LOFT CRAG
2238ft (682m)

HARRISON STICKLE
2415ft (736m)

PIKE O'STICKLE
2323ft (708m)

THORN CRAG
2200ft (671m)

Elterwater and the Langdale Pikes

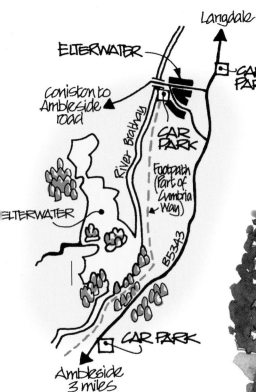

Elterwater lake is less than a half mile long, with a width that varies hugely with the rainfall, and a maximum depth of about 70 feet.

There's a pleasant walk of only about a mile long from the car park in Elterwater village to the lake. There's also a closer car park discretely located in woodland off the B5343 road.

Elterwater lake is a reedy combination of three tarns and compared to the other more grand lakes, a bit of a disappointment. Fortunately, the Langdale Pikes are always on hand to make a good background. A considerable amount of water flows down Brathay Beck and after rain Elterwater can double in size. It has risen as much as five feet in a night.

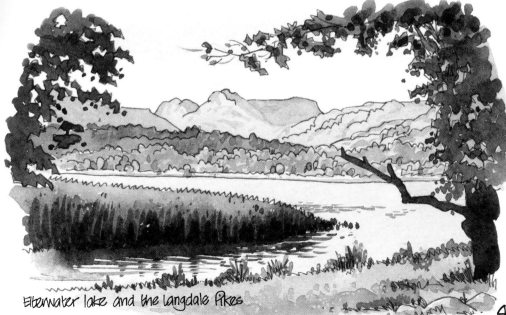

Elterwater lake and the Langdale Pikes

47

# GREAT LANGDALE

The five mile long valley of Great Langdale curves in a lazy S-bend from the low hills around Elterwater to some of the district's most rugged crags at its head. The scenery is spectacular and on a grand scale.

The valley's main village, Chapel Stile, is mainly residential but has a pub, Wainwright's Inn, and an interesting church, Holy Trinity, built into the fellside in 1857 to replace a chapel of 1750.

Langdale is blessedly untouched by modern development; even the road is narrow and twisting, and the main facilities at Dungeon Ghyll have a delightfully old-fashioned charm about them. There are two hotels; the old (over 300 years old) and the 'new' Dungeon Ghyll Hotels (built in 1862).

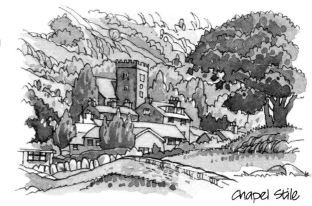

Chapel Stile

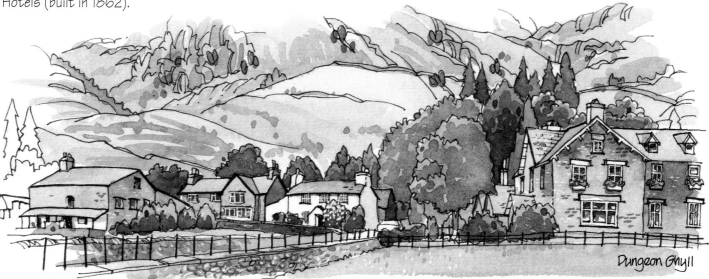

Dungeon Ghyll

48

A long spur of fellside, The Band, splits upper Langdale into two parts; Oxendale, where the narrow road climbs past the delectable Blea Tarn into Little Langdale, and Mickleden, a barren highway for walkers taking the Stake Pass route into Borrowdale.

The magnificent Langdale Pikes dominate the valley, their famous profile unmistakable from miles around. A popular walk is the steep climb up Stickle Ghyll to Stickle Tarn, dammed in 1838 to maintain a head of water for the Elterwater Gunpowder Factory. The huge bastion of Pavey Ark - one of the grandest sights in Lakeland - looms over the water.

Pike o Stickle, on the NW corner of the Pikes was declared a 5,000 year old axe factory in 1947 when Neolithic stone axe heads were discovered in a gully.

The car parks at Dungeon Ghyll fill up quickly but one of the best ways to enjoy Langdale is to walk the Cumbria Way along the mainly flat valley floor from Skelwith Bridge, and return on the local bus. But check the bus times before setting out!

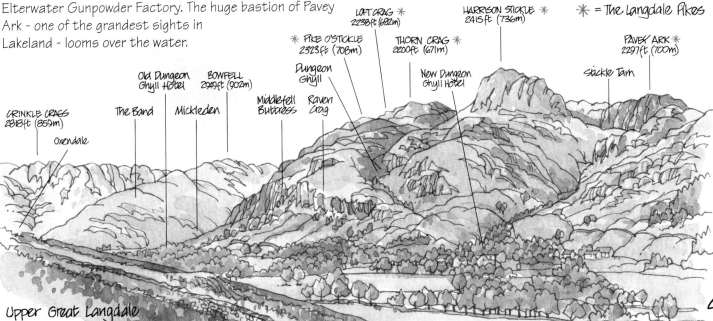

✴ = The Langdale Pikes

LOFT CRAG ✴
2238ft (682m)

HARRISON STICKLE ✴
2415ft (736m)

✴ PIKE O'STICKLE
2323ft (708m)

THORN CRAG ✴
2200ft (671m)

PAVEY ARK ✴
2297ft (700m)

Dungeon Ghyll

New Dungeon Ghyll Hotel

Stickle Tarn

Old Dungeon Ghyll Hotel

BOWFELL
2949ft (902m)

Middlefell Buttress

Raven Crag

CRINKLE CRAGS
2818ft (859m)

The Band

Mickleden

Oxendale

Upper Great Langdale

49

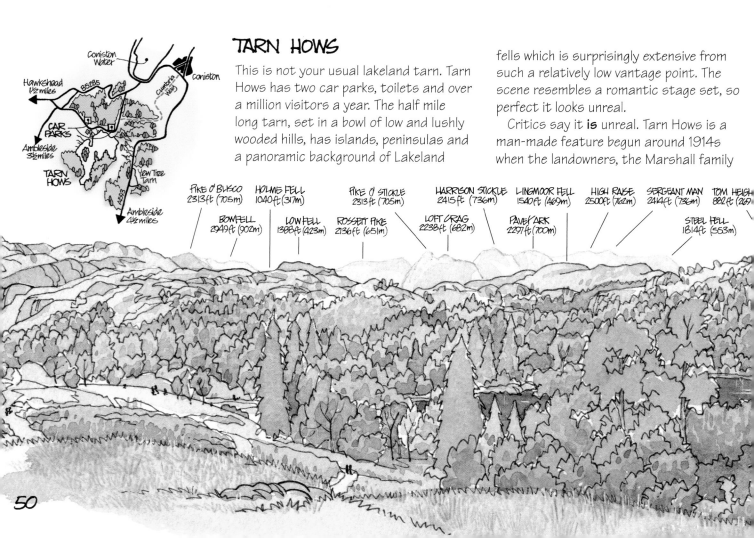

# TARN HOWS

This is not your usual lakeland tarn. Tarn Hows has two car parks, toilets and over a million visitors a year. The half mile long tarn, set in a bowl of low and lushly wooded hills, has islands, peninsulas and a panoramic background of Lakeland fells which is surprisingly extensive from such a relatively low vantage point. The scene resembles a romantic stage set, so perfect it looks unreal.

Critics say it **is** unreal. Tarn Hows is a man-made feature begun around 1914s when the landowners, the Marshall family

*Map labels:*
Coniston Water
Coniston
Hawkshead 1½ miles
B5285
Cumbria Way
CAR PARKS
Ambleside 3½ miles
TARN HOWS
Yew Tree Tarn
A593
Ambleside 4½ miles

*Panorama fell labels:*
PIKE O' BLISCO 2313ft (705m)
BOWFELL 2949ft (902m)
HOLME FELL 1040ft (317m)
LOW FELL 1388ft (423m)
PIKE O' STICKLE 2313ft (705m)
ROSSETT PIKE 2136ft (651m)
HARRISON STICKLE 2415ft (736m)
LOFT CRAG 2238ft (682m)
LINGMOOR FELL 1540ft (469m)
PAVEY ARK 2297ft (700m)
HIGH RAISE 2500ft (762m)
SERGEANT MAN 2414ft (736m)
TOM HEIGH 882ft (269m)
STEEL FELL 1814ft (553m)

of Monk Coniston Hall, built a dam and converted a number of small tarns and marshy ground into one tarn with two little islands. In 1929, the 4,000-acre Monk Coniston Estate which included Tarn Hows was put up for sale. To prevent the estate being broken up it was bought by Beatrix Potter in 1930, who sold half of the Tarn Hows area on to the National Trust at cost and bequeathed the other half. Extensive landscaping, hard footpaths and footbridges makes it even more artificial every year. Nevertheless, despite its detractors and the sometimes over-crowding, Tarn Hows on a bright, crisp morning is a scene of rare and unforgettable beauty.

There's an excellent scenic footpath from Coniston to Tarn Hows, a two-mile stretch of the Cumbrian Way.

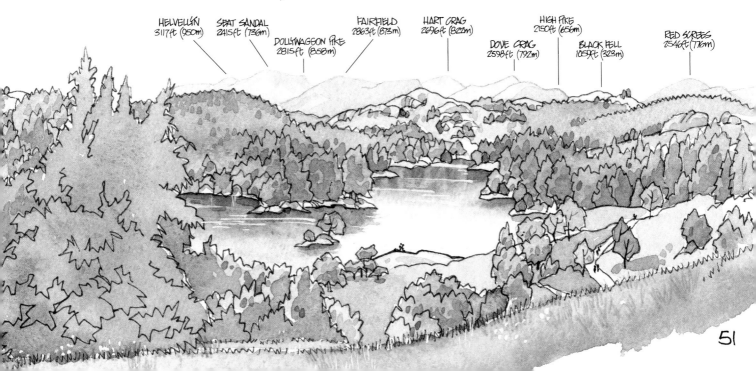

HELVELLYN 3117ft (950m)

SEAT SANDAL 2415ft (736m)

DOLLYWAGGON PIKE 2815ft (858m)

FAIRFIELD 2863ft (873m)

HART CRAG 2696ft (822m)

DOVE CRAG 2598ft (792m)

HIGH PIKE 2150ft (656m)

BLACK FELL 1059ft (323m)

RED SCREES 2546ft (776m)

# CONISTON

Though well off the A591 main tourist track through Lakeland, Coniston still manages to attract its fair share of visitors and retain a slightly old-fashioned appeal. The grey slate village is dominated by rugged fells and Coniston Water lies nearby. Tourism is now the main industry and Coniston has everything you'd expect from a place that makes its living from catering to visitors.

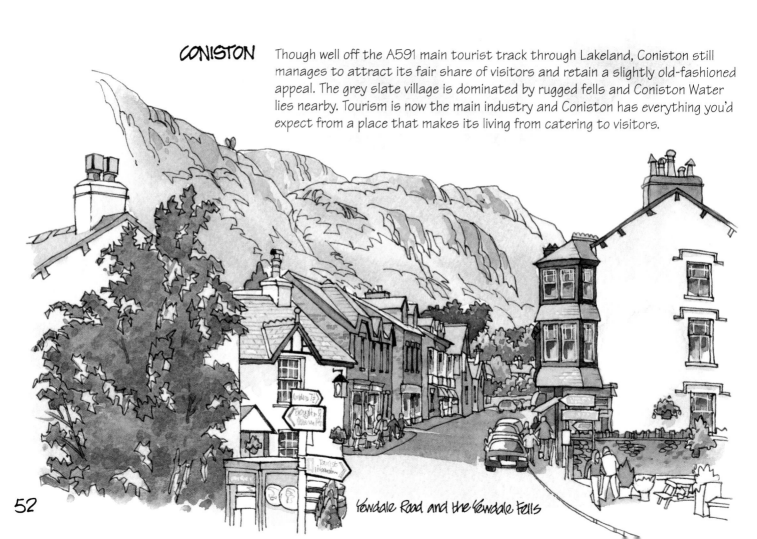

*Yewdale Road and the Yewdale Fells*

Coniston has a strong industrial background. The copper mines, for which the area is renowned, probably date from Norman times, but were most prosperous from the 16th century when German miners worked here.

Iron ore was also mined and the lake used for transportation. Church Beck flows through – and occasionally floods – the village from a source in the main valley high in the fells, still known as Coppermines Valley. By the end of the First World War, mining at Coniston had almost completely died out, although slate quarrying in the area continues to this day.

A railway branch line from Broughton-in-Furness opened in 1859, but was unpopular with tourists and closed in 1957.

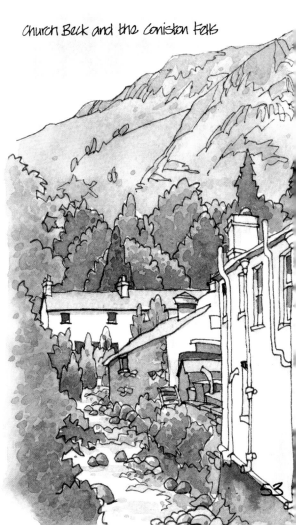

Church Beck and the Coniston Fells

Over Church Beck bridge

53

# CONISTON WATER

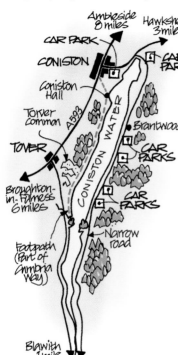

Ambleside 8 miles
Hawkshead 3 miles
CAR PARK
CONISTON
CAR PARK
Coniston Hall
Torver Common
A593
Brantwood
TORVER
CAR PARKS
CAR PARKS
Broughton-in-Furness 6 miles
CONISTON WATER
Narrow road
Footpath (Part of Cumbria Way)
Blawith 1 mile

**Coniston Water**
**Length** 5.5 miles
**Maximum width** 0.5 mile
**Maximum depth** 184ft
Five small islands

The Coniston fells command the western side of the lake and the dark green blanket of the Grizedale Forest clothes the eastern hills.

As one of the longest straight stretches of placid water in the Lakes, Coniston Water was chosen by Donald Campbell for his ill-fated attempt at the world water-speed record in 1967. His jet-powered boat, Bluebird, back-flipped at over 300mph and sank. Campbell's body and the wreck of Bluebird were retrieved from the lake in 2001. His remains are interred in Coniston church yard.

Built in 1856, the steam yacht *Gondola* sailed on Coniston until decommissioned in 1936. After running aground during a storm in the 1960s, she was left to rot at the lakeside. Eventually, the National Trust restored the vessel and brought her back into service in 1980. Originally coal-burning, *Gondola* is now more green and since 2008 has been fired on compressed sawdust logs. She carries up to 86 passengers a trip up and down Coniston in considerable luxury.

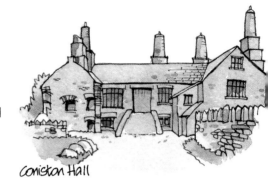

Coniston Hall

Coniston Hall was built around 1250 and was a residence of the Fleming family until 1408. When they left the hall became a farmhouse. The National Trust bought the estate in 1972 and the grounds were turned into a camp site. The hall is gradually being restored.

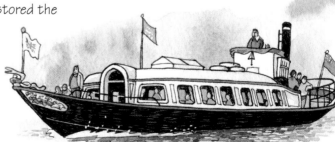

Gondola

The supreme arbiter of Victorian taste, John Ruskin, bought Brantwood in 1871 without ever seeing the house. 'Any place opposite Coniston Old Man must be beautiful', he said. Not necessarily – it turned out that the house was damp and decayed, little more than the original rough cast cottage built at the end of the 1700s. However, over the last thirty years of his life, Ruskin turned Brantwood into a fine country house with an estate of over five hundred acres. It's now open to the public as a museum and Ruskin memorial. The fell view across the lake is little changed, just with more trees and boats. Brantwood has a fine tearoom and *Gondola* calls regularly at the stone pier below the house.

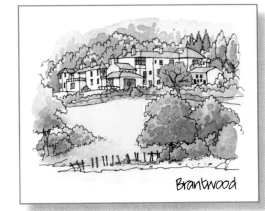

Brantwood

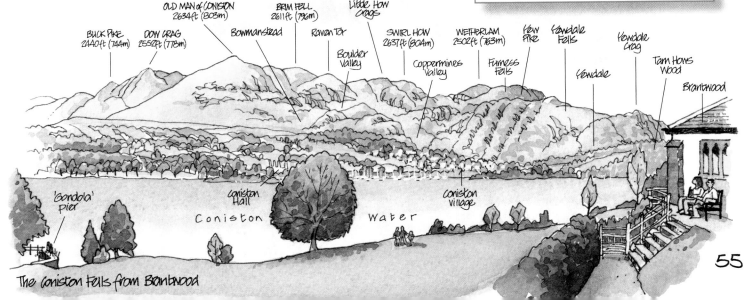

BUCK PIKE 2440ft (744m)
DOW CRAG 2552ft (778m)
OLD MAN of CONISTON 2634ft (803m)
Bowmanstead
BRIM FELL 2611ft (796m)
Raven Tor
Boulder Valley
LITTLE HOW CRAGS
SWIRL HOW 2637ft (804m)
Coppermines Valley
WETHERLAM 2502ft (763m)
Furness Fells
Pew Pike
Yewdale Fells
Yewdale
Yewdale Crag
Tarn Hows Wood
Brantwood

'Gondola' Pier
Coniston Hall
Coniston Water
Coniston Village

The Coniston Fells from Brantwood

55

# HAWKSHEAD

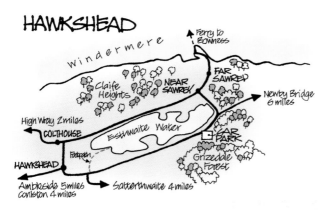

With the character of a small market town rather than a village, Hawkshead's compact, uncoordinated arrangement of ancient whitewashed buildings, cobbled pavements and squares, and narrow streets with low archways leading to secluded courtyards, is a joy to explore. Traffic is banned from the village but there's a huge car park on the outskirts to cater for the multitude of visitors. Hawkshead is unlike any other village (or town) in the Lake District. Also uniquely, it has connections with both William Wordsworth **and** Beatrix Potter.

Miss Potter married a Hawkshead solicitor, William Heelis, at the age of 47 in 1913. The former Heelis offices still stand in the old Main Street.

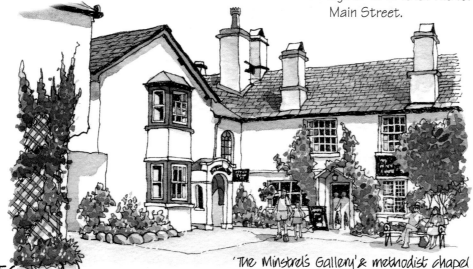

'The Minstrel's Gallery' & methodist chapel

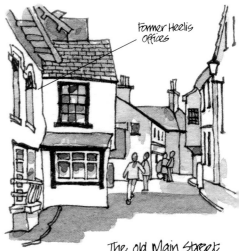

Former Heelis offices

The old Main Street

The Grammar School was founded in 1585 by Edward Sandys, a locally-born cleric who Queen Elizabeth made Archbishop of York. William Wordsworth attended the school from 1779-87.

Although he was born at Cockermouth in 1770, after his mother's death in 1778 the boy William was sent to school at Hawkshead and lodged in the care of Ann Tyson.

The school is now a museum and library. Star attraction is Wordsworth's school desk – complete with his carved initials – encased in glass.

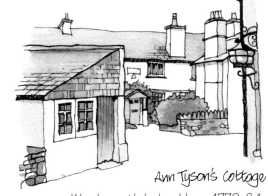

Ann Tyson's Cottage

Wordsworth lodged here 1779-84, then moved with Mrs Tyson to Colthouse after her husband died.

The Church of St Michael stands on a grassy hill overlooking the village. Long and low, the present building replaced an ancient chapel in the 15th century. The schoolboy Wordsworth wrote of its 'snow-white' walls in verse, but they have been an unpoetic gray ever since the rendering was removed in 1875.

The Grammar School & St Michael's church

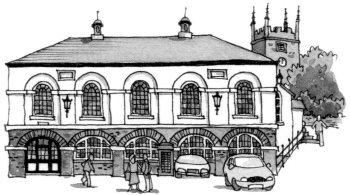

### The Town Hall

During the 18th and 19th centuries Hawkshead was the administration centre for the area. The Town Hall was built in 1790 and the five open-arched shops at square level were occupied on market days by butchers.

King's Arms Hotel

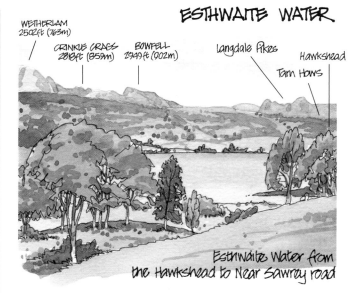

# ESTHWAITE WATER

WETHERLAM
2502ft (763m)

CRINKLE CRAGS
2818ft (859m)

BOWFELL
2949ft (002m)

Langdale Pikes

Hawkshead

Tarn Hows

Esthwaite Water from the Hawkshead to Near Sawrey road

Only one and a half miles long, a half-mile wide and 80 feet deep, Esthwaite Water is one of the smallest and least visited of the region's lakes. But if you like solitude, pretty countryside, low fells and minor roads, this is the place for you. It is said to have been a favourite of Wordsworth when he was a schoolboy at Hawkshead. There's a footpath from the village to the north end of the lake and a car park with access at the south. The vast acres of Grizedale Forest stretch away to the south west.

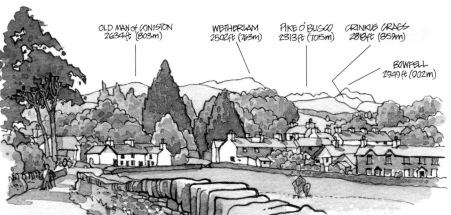

OLD MAN of CONISTON
2634ft (803m)

WETHERLAM
2502ft (763m)

PIKE O' BLISCO
2313ft (705m)

CRINKLE CRAGS
2818ft (859m)

BOWFELL
2949ft (902m)

Tower Bank Arms

# NEAR SAWREY

*From the road to Far Sawrey*

Beatrix Potter bought Hill Top Farm at Near Sawrey in 1903 using the proceeds from her early *Peter Rabbit* books to escape her restrictive family life in London. The village is rather ordinary, which suited Beatrix, and she turned the farmhouse into an artist's retreat. After marriage to William Heelis she made a permanent home in the village at Castle Cottage and devoted the rest of her life to farms, Herdwick sheep and the countryside. She died at the age of 78 leaving 15 farms and 4,000 acres of land to the National Trust.

   An illustration of the Tower Bank Arms appears in *The Tale of Jemima Puddle-Duck* and the pub is the village's only amenity. Hill Top is open to the public just as Beatrix left it.

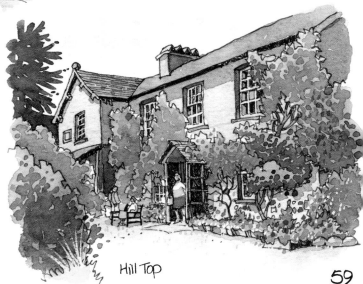

Hill Top

59

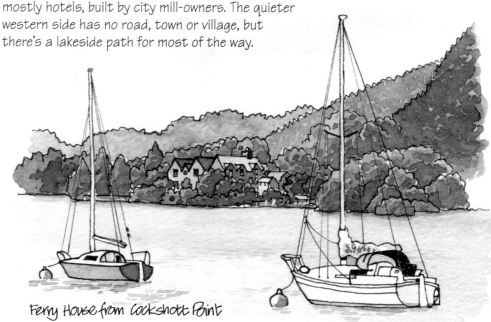

## Map labels

Patterdale
via Kirkstone Pass
- 'The Struggle'
8 miles

Grasmere
4 miles

Patterdale
via Kirkstone
Pass 11 miles

**AMBLESIDE
CAR PARKS**

Waterhead

Brockhole
**CAR
PARK**

A592

**TROUTBECK**

Wray Castle
**CAR PARK**

WINDERMERE!

B5286

Coniston
11 miles

**WINDERMERE
CAR PARK** ASS'

**HAWKSHEAD
CAR PARK**

Claife
Heights

Belle
Isle

Kendal
9 miles

Grizedale
Forest

**BOWNESS
CAR PARKS**

Car Ferry

Esthwaite
Water

**SAWREY**

Levens
via Winster
8 miles

Narrow
road

A592

Lakeside
**CAR PARK**

Fell Foot
**CAR PARK**

Grange-over-Sands
6 miles

R. Leven

A590

**NEWBY BRIDGE**

Ulverston
9 miles

## WINDERMERE

| | |
|---|---|
| Length | 11.25 miles |
| Maximum width | 1 mile |
| Maximum depth | 219ft |

18 islands, one inhabited - and private

60

# WINDERMERE

As befits the country's largest lake, Windermere has a stately air and is named after a Norse hero, *Vinandr*. The largest of the lake's 18 islands, Belle Isle, almost cuts the lake in two at Bowness. In ancient times it was a busy Roman highway and later used to transport Iron ore and charcoal. These days all manner of boats scrummage for a stretch of clear water. Large power boats were effectively banned from the lake when a 10mph speed limit became effective in 2005.

The shoreline is well wooded and the eastern side dotted by large mansions, now mostly hotels, built by city mill-owners. The quieter western side has no road, town or village, but there's a lakeside path for most of the way.

Ferry House from Cockshott Point

There's been a Windermere ferry for at least 500 years. The early ones were large rowing boats often dangerously overloaded. One overturned in 1637 drowning 47 people returning from a wedding in Hawkshead. They were buried in a mass grave in Bowness churchyard.

The first steam ferry to run on cables was introduce in 1870. The latest model has been in service since 1990, running all year round from Bowness Nab across 550 yards to Ferry House, headquarters of the Freshwater Biological Society, and cutting at least an hour off the road journey around the lake.

The town of Windermere grew around the railway station – over a mile from the lakeshore at Bowness – after the branch line from Oxenholme opened in 1847.

Belle Isle House

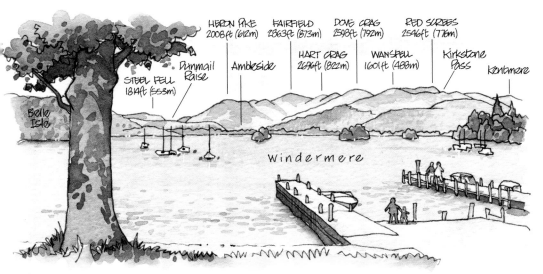

View north from the marina

The beautiful house on Belle Isle is said to be the only truly round house in England. The present building dates from 1774 and was ravaged by fire in 1996. It's now restored and inhabited but strictly private. You can catch a glimpse of the house through the trees from Cockshot Point.

61

# BOWNESS

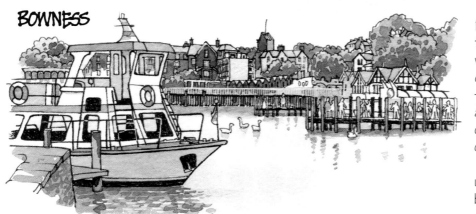

Rising steeply on the way to the town of Windermere, Crag Brow is the vibrant centre of the Bowness shopping experience. There are 'proper' shops too – even galleries and a bookshop – and an absence of the lines of cheap outdoor clothing shops which blight the streets of Keswick and Ambleside.

The town's reputation may be undeserved. A visit to Bowness can be a good day out – when it's not overcrowded.

Bowness has been unkindly called the 'Blackpool of the Lakes'. On a sunny bank holiday there may be some truth in it as thousands of visitors eager 'for a day in the Lakes' target the sprawling lakeside town.

The Vikings originally settled here in the 11th century and until the coming of the railway Bowness was little more than a few fisherman's cottages. Then, with easier and quicker access, tourists flooded in and have never stopped coming since. From lake cruises to gift shops, pubs and fish and chips, there's plenty to amuse but, as cynics might say, Bowness is hardly representative of the Lake District as a whole.

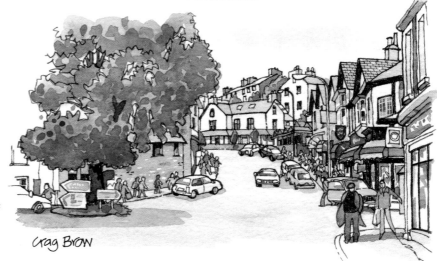

Crag Brow

Bowness does have a quieter side and a walk around the narrow streets of the old town behind the church, known as Lowside, gives an idea what the place was like before the tourist invasion.

New Hall Inn is locally know as 'Hole int' Wall' from the time when there was a smithy next door and ale was served to the smiths through a hole in the wall. The inn is one of the original three which stood on the old road through the town. A sign on the outside wall boasts it was 'frequented by Charles Dickens'. Another sign says that from 1852 to 1860 the landlord was Thomas Longmire, 'champion wrestler of England and holder of 174 titles'.

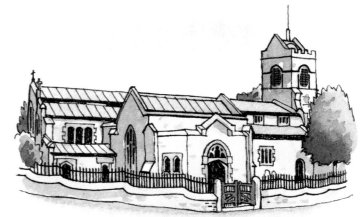

St Martin's church

A church has stood on the site of St Martin's since 1203, although the present building dates back to 1436. The entire roof is unusually covered with lead, transported over Wrynose Pass by a local man without payment. His patronage is commemorated by a tiny piece of glass in one of the windows. Medieval glass from Cartmel Priory was brought here for safety during the Dissolution and incorporated into the east window, St Martin's greatest treasure.

The churchyard was consecrated during the Great Plague of 1348 and some of the yew trees are over 600 years old. Burials ceased here in 1856.

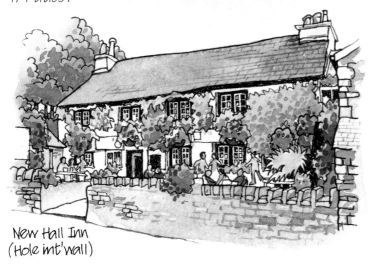

New Hall Inn
(Hole int'wall)

63

# TROUTBECK

Clinging to the hillside of a long, green valley north of Windermere, Troutbeck is a series of picturesque hamlets; Townhead, High Green and Townend, strung along a mile of an old pack-horse highway from Ambleside to Kentmere and linked by a network of footpaths and lanes. Many of the houses are 17th century and some still have spinning galleries and mullioned windows. A modern road runs along the valley bottom, bypassing the village and leaving it in peace for walkers and lovers of vernacular architecture, for whom Troutbeck is endlessly fascinating.

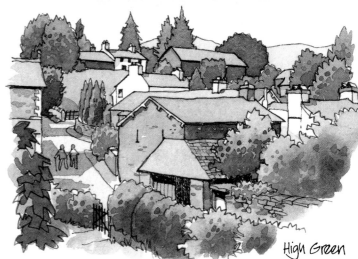

High Green

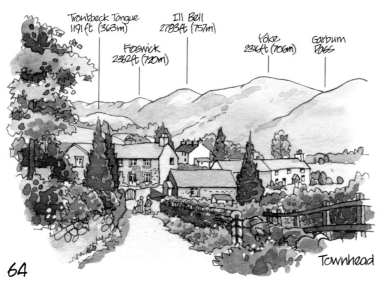

Troutbeck Tongue 1191ft (363m)  
Ill Bell 2783ft (757m)  
Froswick 2362ft (720m)  
Yoke 2316ft (706m)  
Garbum Pass

Townhead

Troutbeck has a Post Office and tea room at its centre but parking is difficult throughout the village. There are two pubs, the Mortal Man at High Green and the Queen's Head Hotel on the main road at Townhead.

The village church stands beside the main road and has the distinction of not having a patron saint, being simply called 'Jesus Church' instead. Built in 1736 on the site of an older building, it has a stained glass window designed by Edward Burne-Jones, assisted by fellow pre-raphaelite artists, Ford Maddox Brown and William Morris while they were on holiday here.

64

Townend, a large white house at the southern end of Troutbeck, was originally a statesman farmer's home, dating from 1626. It remained in the Browne family until being given to the National Trust in 1947. Most of the contents remain intact, a remarkable record of one prosperous family's history. There's no electricity in the house, so it's only open to the public during daylight.

The Brownes stored wool fleeces in the magnificent bank barn across the road until they were sold to merchants.

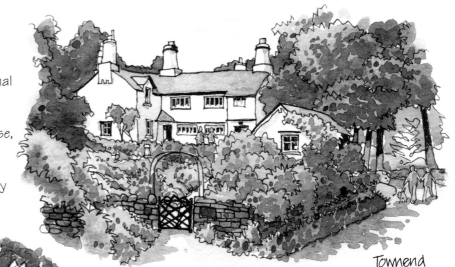

Townend

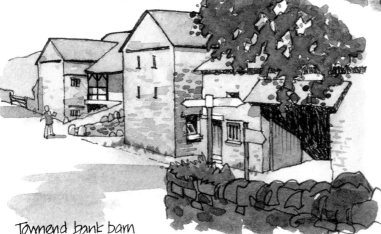

Townend bank barn

'Jownie Wife House'

# KIRKSTONE PASS

Historically a drovers track, Kirkstone Pass connects Windermere and Ambleside with Patterdale. At 1,489ft (440m) high on A592 road, it's the highest motor pass in the district.

The climb out of Ambleside is particularly steep with some awkward corners needing carefully attention, even in a modern car. The ascent from Windermere is more rural with some fine views into the upper Troutbeck valley. The Patterdale side is also steep but the road is more broad and sweeping.

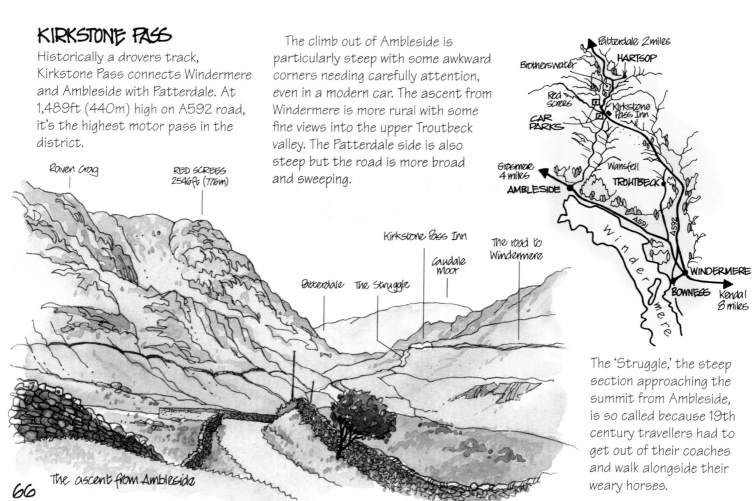

Patterdale 2 miles
HARTSOP
Brotherswater
Red Screes
Kirkstone Pass Inn
CAR PARKS
Grasmere 4 miles
AMBLESIDE
Wansfell
TROUTBECK
A591
A592
WINDERMERE
BOWNESS
Kendal 8 miles
Windermere

Raven Crag

RED SCREES 2546ft (776m)

Kirkstone Pass Inn

The road to Windermere

Caudale Moor

Patterdale    The Struggle

The 'Struggle,' the steep section approaching the summit from Ambleside, is so called because 19th century travellers had to get out of their coaches and walk alongside their weary horses.

The ascent from Ambleside

66

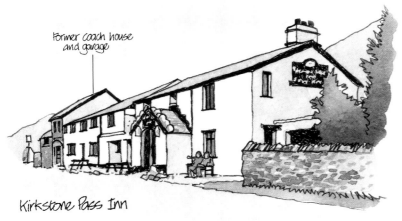

Former coach house and garage

Kirkstone Pass Inn

Kirkstone Pass Inn stands at the summit of the pass and was once an important coaching stop. Now catering primarily for tourists, it enjoys the highest location of any public house in Cumbria and the third highest in England. The building dates back to 1496 and in the 1950s the present staff accommodation served as a garage with petrol pumps and a forecourt.

There's a large car park at the summit and, apart from the attractions of the inn, a stop to take in the views – and the often breezy fresh air – is mandatory. The eye is immediately caught by Windermere languishing way down Stock Gill. A short walk across the summit reveals the classic northern view down the pass to Brotherswater and Patterdale. There's also a car park on this side from where you can enjoy the aspect in comfort.

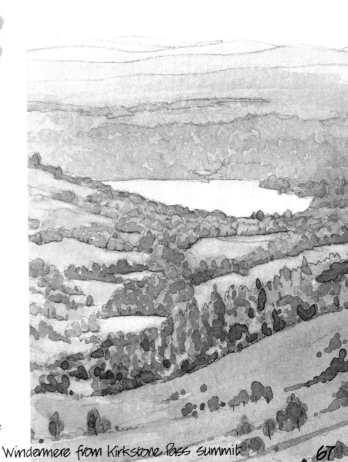

Windermere from Kirkstone Pass summit

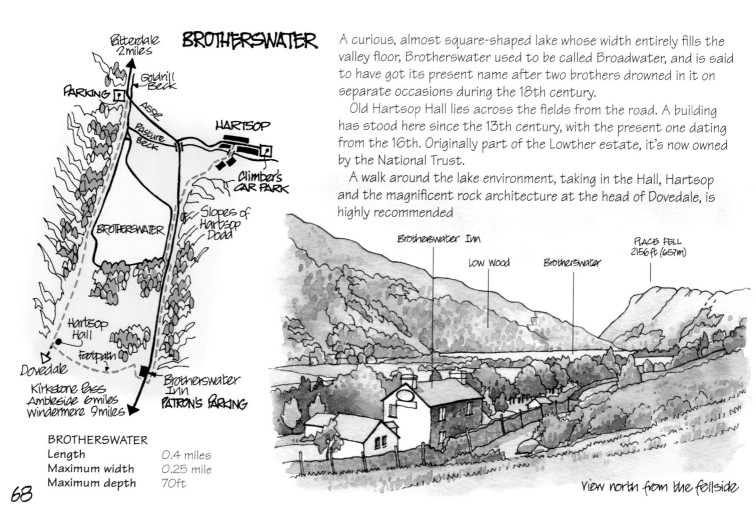

# BROTHERSWATER

Patterdale 2 miles

Goldrill Beck

PARKING

A592

Pasture Beck

HARTSOP

Climber's Car Park

Slopes of Hartsop Dodd

BROTHERSWATER

Hartsop Hall

Footpath

Dovedale

Kirkstone Pass
Ambleside 6 miles
Windermere 9 miles

Brotherswater Inn
PATRON'S PARKING

**BROTHERSWATER**
Length 0.4 miles
Maximum width 0.25 mile
Maximum depth 70ft

A curious, almost square-shaped lake whose width entirely fills the valley floor, Brotherswater used to be called Broadwater, and is said to have got its present name after two brothers drowned in it on separate occasions during the 18th century.

Old Hartsop Hall lies across the fields from the road. A building has stood here since the 13th century, with the present one dating from the 16th. Originally part of the Lowther estate, it's now owned by the National Trust.

A walk around the lake environment, taking in the Hall, Hartsop and the magnificent rock architecture at the head of Dovedale, is highly recommended

Brotherswater Inn

Low Wood

Brotherswater

PLACE FELL 2156ft (657m)

View north from the fellside

68

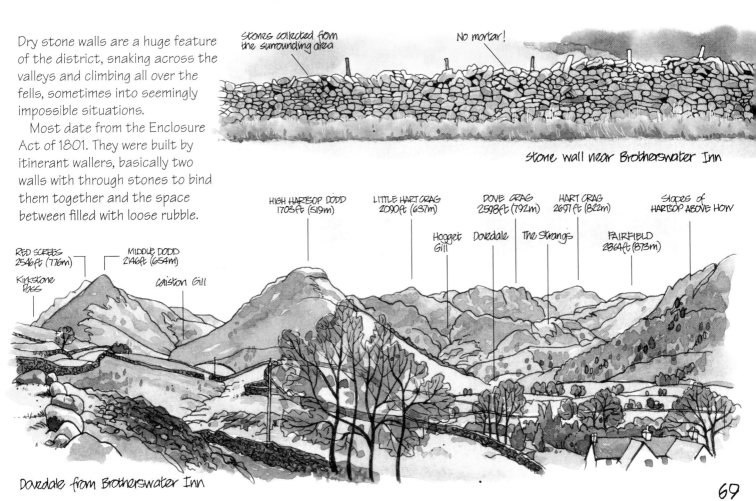

Dry stone walls are a huge feature of the district, snaking across the valleys and climbing all over the fells, sometimes into seemingly impossible situations.

Most date from the Enclosure Act of 1801. They were built by itinerant wallers, basically two walls with through stones to bind them together and the space between filled with loose rubble.

stones collected from the surrounding area

No mortar!

Stone wall near Brotherswater Inn

RED SCREES 2546ft (776m)

Kirkstone Pass

MIDDLE DODD 2146ft (654m)

Caiston Gill

HIGH HARTSOP DODD 1703ft (519m)

LITTLE HART CRAG 2090ft (637m)

Hogget Gill

DOVE CRAG 2598ft (792m)

Dovedale

HART CRAG 2697ft (822m)

The Strangs

slopes of HARTSOP ABOVE HOW

FAIRFIELD 2864ft (873m)

Dovedale from Brotherswater Inn

69

# HARTSOP

A delightful hamlet, snuggled between steep fells in a cul-de-sac at the southern end of Patterdale, Hartsop was once the biggest settlement and centre of industry in the valley. Renowned for wool spinning, it also had corn and cloth mills with tailors, cobblers and blacksmiths looking after the needs of the locally-based miners.

These days the 17th century, grey-stone cottages are quiet, their spinning galleries prettified with potted plants; only the sounds of sheep, the tinkling of Pasture Beck and the occasional yap of a farm dog disturbs the refined air.

Low House Farm

High Beckside

70

The 17th century Low House Farm on the approach to the village is a splendid example of a vernacular architecture Lakeland farmstead, where a barn and cattle shed were built at the opposite ends of the house to keep the humans warm.

Fell Yeat was once the Bunch o' Birks Inn on a pack horse trail that still crosses the beck at a ford, before winding its sinuous way to Kirkstone Pass.

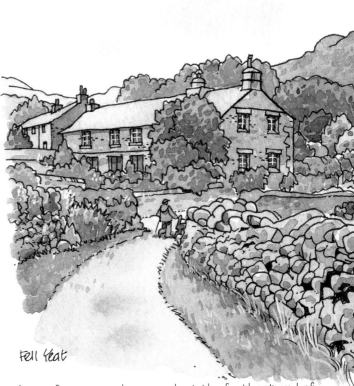

Fell Yeat

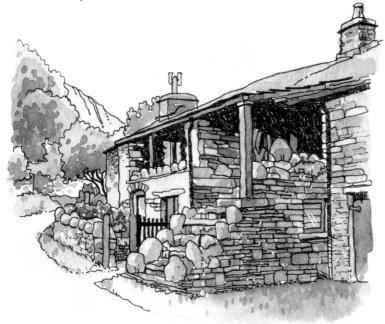

A cottage with a stepped spinning gallery

Apart from a rough car park at the farthest end of the village, where a wide track sweeps up the valley to Hayeswater, there are no other facilities. But with a place as picturesque as Hartsop, 'facilities' would only be a vulgar intrusion.

71

# PATTERDALE

Many people's favourite Lakeland valley, Patterdale stretches for three miles from Kirkstone Pass to Ullswater. The narrow band of farmland twists through an avenue of fells, while Goldrill Beck flows attractively out of Brotherswater and the A592 road winds through mixed woodland and pasture.

It's always busy in summer, but there's a quiet walking track from Hartsop to Patterdale along the eastern side of the valley with fine views of the dale, Ullswater and the Helvellyn range of fells.

Patterdale is prone to flooding after heavy rain and was particularly badly hit by the big downpour of November 2009.

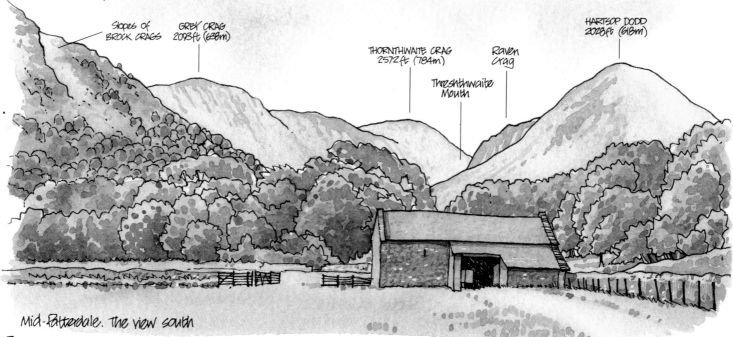

Mid-Patterdale. The view south

Three delightful small dales go off to the west of the main valley. Grisedale rises from the village of Patterdale and the track to the famous Striding Edge route to Helvellyn begins here. Grisedale Hause, between Fairfield and Seat Sandal, goes all the way over to Grasmere.

Deepdale and Dovedale cut deep into the fells and both have a superb arrangement of crags at its head.

Deepdale begins at Deepdale Bridge which crosses a lively beck flowing out of the valley. The lower end has a flat strath of pasture and a few habitations, but beyond the the last farm, Wallend, the landscape becomes a savage rocky extravaganza as awesome as neighbouring Dovedale.

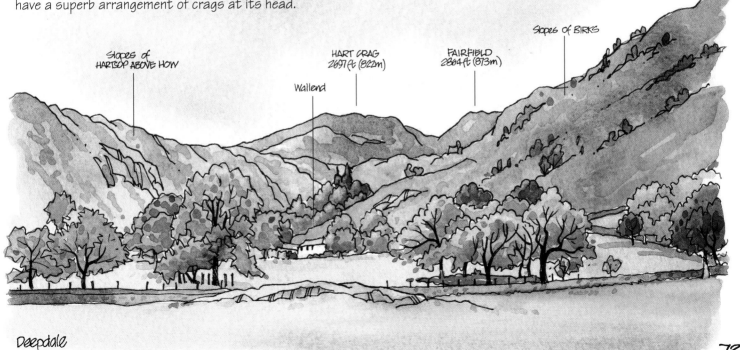

Slopes of
HARTSOP ABOVE HOW

Wallend

HART CRAG
2697ft (822m)

FAIRFIELD
2864ft (873m)

Slopes of BIRKS

Deepdale

# PATTERDALE VILLAGE

Patterdale is a widely scattered village almost seamlessly joined to Glenridding. Though not unattractive, both villages are hugely popular for their location and teem with boot-shod visitors all the year round.

Patterdale retains a slightly old-fashioned air and still has a busy village store and post office. The wedge-shaped White Lion Inn, set at a bottleneck in the main road, is a popular (though not with motorists!) landmark.

With the natural barriers of Kirkstone Pass at one end and Ullswater at the other, Patterdale is relatively inacessible. It wasn't until 1920 that a metalled through road was established when part of Stybarrow Crag was blasted away to make room for a road alongside the lake.

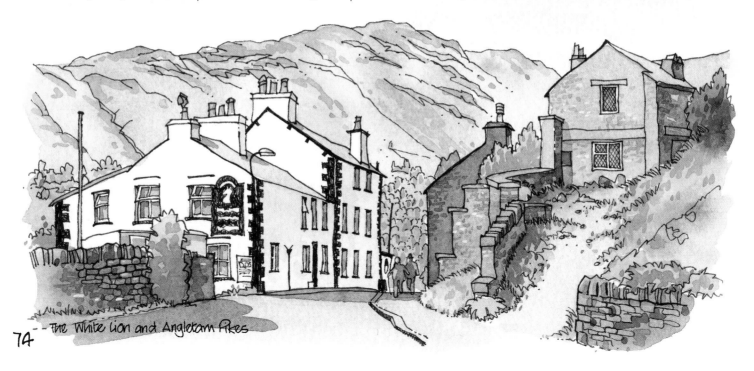

The White Lion and Angletam Pikes

74

# GLENRIDDING

Now a service area for the thousands of visitors who make the village their base for exploring the surrounding fells, during the 19th century Glenridding was the centre of a huge mining operation. Gold and silver were found but the Greenside mine, at the head of Glenridding Beck, was exceptionally rich in lead. The mines were finally worked out in 1962. The last level ran for 3,000 feet (915m) into the Helvellyn range. Greenside was most productive of the Lake District mines, with a record 300 years of continuous production.

The Ullswater steamer pier is based on a stoney peninsular left when a dam, built to provide power for the mines, burst at Kepple Cove in 1927. Tons of water and rubble swept down Glenridding Beck into the lake, bringing devastation to the village in its path.

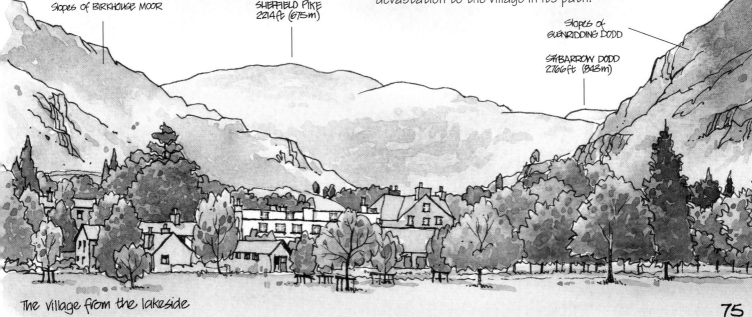

Slopes of BIRKHOUSE MOOR

SHEFFIELD PIKE
2214ft (675m)

Slopes of
GLENRIDDING DODD

STYBARROW DODD
2766ft (843m)

The village from the lakeside

75

# ULLSWATER

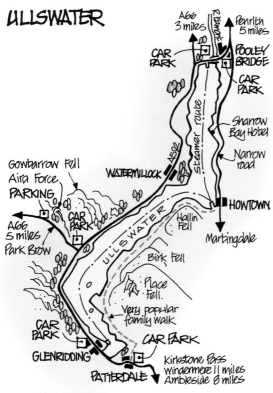

For many people the finest of all the lakes, Ullswater has the shape of an elongated 'Z' with three distinct reaches. There's the gentle, almost boring, landscape at the northern, Pooley Bridge end, the more scenic central section and the full on grandeur and magnificence of the southern part at Glenridding.

A66
3 miles

R. Eamont
Penrith
5 miles

CAR PARK

POOLEY BRIDGE

CAR PARK

Sharrow Bay Hotel

Narrow road

Steamer route

A592

WATERMILLOCK

HOWTOWN

Gowbarrow Fell
Aira Force
PARKING

CAR PARK

A66
5 miles
Park Brow

ULLSWATER

Hallin Fell

Martindale

Birk Fell

Place Fell

Very popular family walk

CAR PARK

CAR PARK

GLENRIDDING

PATTERDALE

Kirkstone Pass
Windermere 11 miles
Ambleside 8 miles

**ULLSWATER**

| | |
|---|---|
| Length | 7.5 miles |
| Maximum width | 0.75 miles |
| Maximum depth | 205ft |
| Five small islands | |

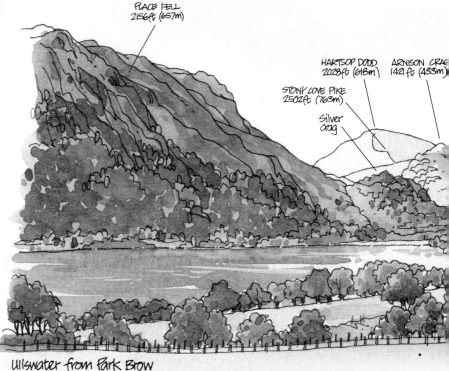

PLACE FELL
2156ft (657m)

HARTSOP DODD
2028ft (618m)

ARNISON CRAG
1421ft (433m)

STONY COVE PIKE
2502ft (763m)

Silver Crag

Ullswater from Park Brow

The view of the southern reach from Park Brow, on the Matterdale road near Aira Force, is justifiably famous and not just for its outstanding scenic qualities.

On this stretch of water in 1955 Donald Campbell set the world waterspeed record, when he piloted the jet-propelled hydroplane Bluebird K7 to a speed of 202.32mph.

The lakeshore below Aira Force is where in 1802 William and Dorothy Wordsworth are reputed to have seen the daffodils which inspired William's most famous piece of poetry. The couple were on their way back to Grasmere after visiting Eusmere, a country house near Pooley Bridge, the home of the anti-slavery campaigner Thomas Clarkson.

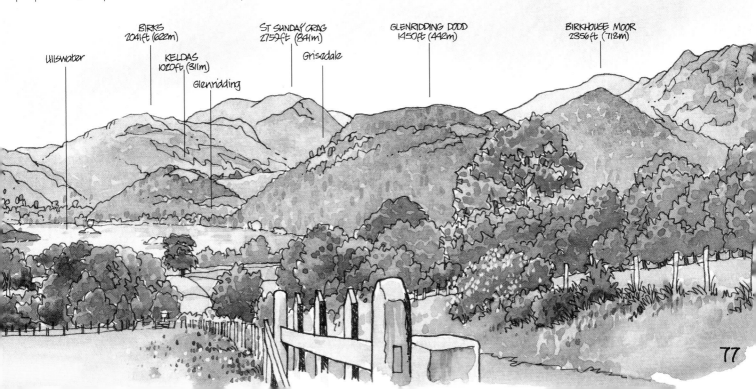

BIRKS
2041ft (622m)

ST SUNDAY CRAG
2759ft (841m)

GLENRIDDING DODD
1450ft (442m)

BIRKHOUSE MOOR
2356ft (718m)

Ullswater

KELDAS
1020ft (311m)

Grisedale

Glenridding

The aspect from the main A592 Pooley Bridge to Glenridding road opens out at the Brackenrigg Inn to a terrific view across a couple of fields to Ullswater and the Howtown Fells beyond.

Howtown is little more than a hotel, a few cottages and a little sailing harbour, but the Ullswater steamers regularly call here, which makes it a vital staging post on one of the most popular family walks in the Lake District. Simply take the streamer from Glenridding to Howtown and walk back on an idyllic footpath of mixed woodland and rocky crags along the eastern lakeshore. You can't get lost – just follow the crowds!

Unlike many of the other big lakes, Ullswater has few lakeside paths and it's difficult to walk off-road around it, which makes the Howtown to Glenridding walking route even more special.

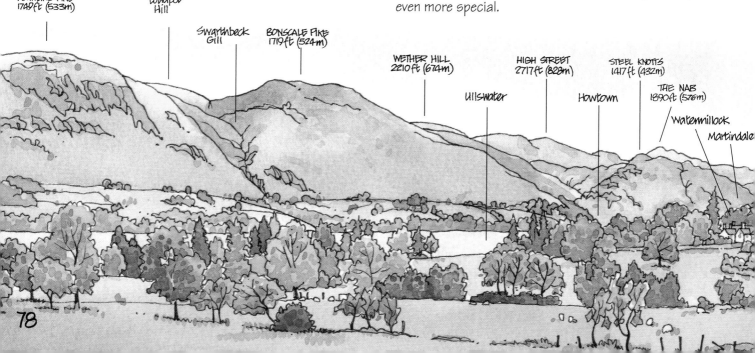

ARTHUR'S PIKE
1749ft (533m)

Loadpot
Hill

Swarthbeck
Gill

BONSCALE PIKE
1719ft (524m)

WETHER HILL
2210ft (674m)

HIGH STREET
2717ft (828m)

STEEL KNOTTS
1417ft (432m)

Ullswater

Howtown

THE NAB
1890ft (576m)

Watermillock

Martindale

Aira Beck rises on the upper slopes of Stybarrow Dodd on the western side of Ullswater. A mile before entering the lake the gentle stream turns into a wild waterfall, Aira Force, plunging 66 feet into a picturesque 'fairy dell' much beloved by Victorian tourists. A small arched bridge spans the stream above the waterfall and provides a spectacular viewpoint as the water gathers speed for its leap.

Aira Force is on National Trust land and it provides full tourist faciliities, including parking and graded walks. It's an excellent place to just wander through the woods or venture further onto the fells.

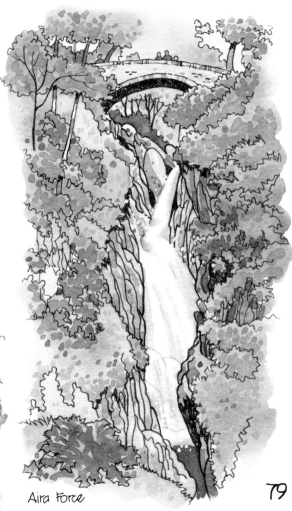

Aira Force

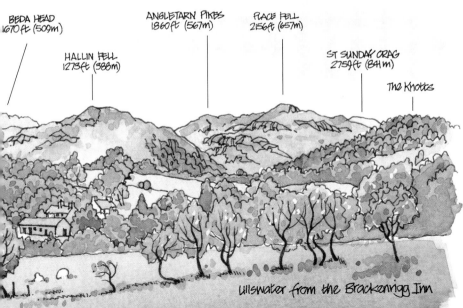

BEDA HEAD
1670ft (509m)

HALLIN FELL
1273ft (388m)

ANGLETARN PIKES
1860ft (567m)

PLACE FELL
2156ft (657m)

ST SUNDAY CRAG
2759ft (841m)

The Knotts

Ullswater from the Brackenrigg Inn

# THE ULLSWATER 'STEAMERS'

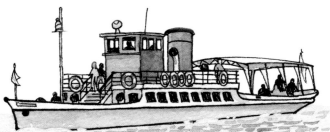

*'Lady of the Lake'*

The 'steamers' are a popular Ullswater attraction providing regular trips up and down the lake calling at Pooley Bridge, Howtown and Glenridding the year round. They were originally working boats which from the 1850s moved mail workers and goods to and from the Greenside lead mine at Glenridding. Today there are four 'steamers' – now diesel powered – plying the tourist trade. *Raven* and *Lady of the Lake* were converted from steam in the 1930s.

*Lady of the Lake* was launched on 26th June 1877 and is believed to be the oldest working passenger vessel in the world.

Directly inspired by the tour operator Thomas Cook, *Raven* was launched on the 11th July 1889.

*Lady Dorothy*, originally a sea going vessel from Guernsey joined the fleet in 2001.

*Lady Wakefield* was built in 1949, now fully restored and renamed by HRH Princess Alexandra in 2007.

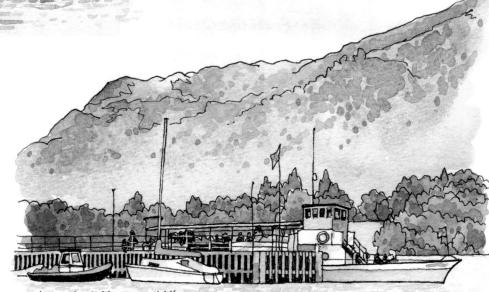

*'Raven' at the Glenridding landing stage*

# POOLEY BRIDGE

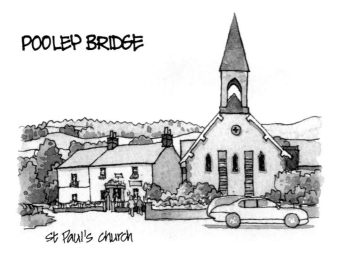

St Paul's church

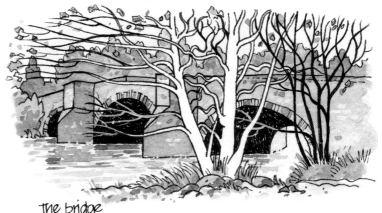

the bridge

Sometimes unkindly branded a 'mini Bowness', Pooley Bridge is a small and busy little village situated at the north end of Ullswater. There's a village shop, numerous gift shops and three pubs, so tourists are well catered for.

St Paul's church is purely Victorian, built in 1868 with, unusual for the Lake District, a sharp steeple.

Pooley's most distinguishing feature is the narrow 16th century bridge, which spans the River Eamont, the outflow of Ullswater, and until the 1974 county reorganisation, the border between Cumberland and Westmorland.

A walk from the village square to the steamer pier reveals a fantastic panoramic view down the lake to the distant high mountains.

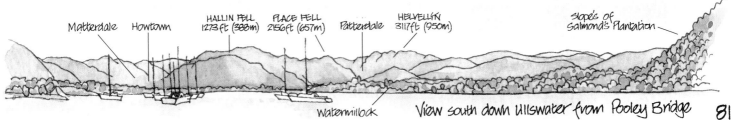

Matterdale   Howtown   HALLIN FELL 1273ft (388m)   PLACE FELL 2156ft (657m)   Patterdale   HELVELLYN 3117ft (950m)   Slopes of Salmond's Plantation

Watermillock

View south down Ullswater from Pooley Bridge

81

Converted brewery and mill buildings

## CALDBECK

Situated in a limestone basin hard up against the northern fells on the edge of the National Park, Caldbeck is a pretty and interesting village, once one of the Lake District's great mining centres.

Fourteen mines, mainly yielding silver, copper and lead, were sunk deep into the wild fells above the village and Caldbeck prospered with more than a dozen mills and a brewery along the River Caldew. Coal for local use was even mined within the village itself from shallow pits on Ratten Row. The last mine closed in 1965.

Since those days the large and scattered village has experienced a considerable amount of 'doing up' but remnants of its industrial past are still evident.

Cottages along the River Caldew

St Kentigern's church

The fine 12th century Church of St Kentigern catches the eye and attracts many visitors, most to see the grave of John Peel, the Lakeland huntsman immortalised in song.

In 1829 a friend of Peel's, John Graves, wrote some words about him which, set to a popular Scottish folk tune, were sung in the local pub, The Oddfellows Arms. After tweaking by the choirmaster of Carlisle Cathedral, William Metcalf, *D'ye ken John Peel* was sung in London and the worldwide hit was born. Peel died of a hunting accident, aged 78 in 1854 and thousands of people turned out for his funeral.

Mary Robinson, the Beauty of Buttermere, is also buried in St Kentigern's churchyard.

These days Caldbeck is largely residential and though visitors are well catered for, the village hasn't been overwhelmed by tourism.

Priest Mill was built on the Caldew in 1702 by the rector and has been converted to craft workshops and an excellent and atmospheric tea room and restaurant, The Watermill Cafe.

Home of John Graves

The Oddfellows Arms on the village square

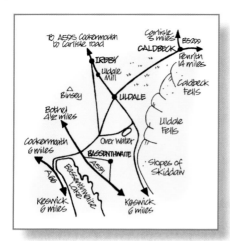

# BACK O' SKIDDA

Between Caldbeck and Uldale a minor road undulates through open, unfenced moorland before descending gradually through farmland to Bassenthwaite. The Caldbeck and Uldale fells to the south are generally dull and featureless and apart from a few scattered farms and the occasional walker taking the low level route of the Cumbria Way, often the only signs of life are the ubiquitous sheep.

And yet there's a lot to be said for solitude. Back o' Skidda, one of the true wilderness areas of the Lake District, is the perfect antidote to the over-crowded, over-commercialised parts of the area.

Uldale is a typical north lakes village; a couple of farms, old cottages converted to desirable residences and a pub, The Snooty Fox, catering for the passing tourist trade, and B&Bs.

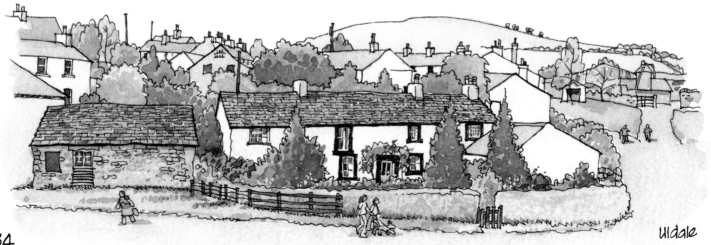

Uldale

St James' church

St James' church enjoys a peaceful location beside the River Ellen at Uldale Mill near the village. The attractive white-painted building dates back to about 1150, although there has been many modifications since.

The actual 'Back of Skiddaw' (or to be strictly accurate, the 'side' of Skiddaw) is a fine sight from the Uldale area. The long ridge of Long Side and Ullock Pike curves dramatically down to Bassenthwaite and the 'secret' valleys of Barkbethdale and Southerndale are revealed.

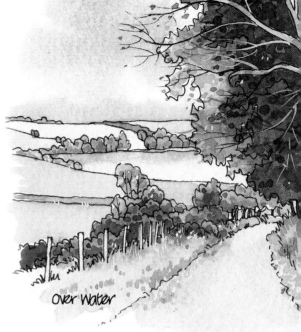

Over Water

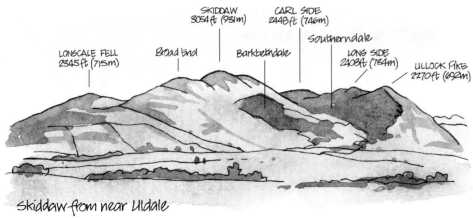

LONSCALE FELL 2345ft (715m)  Broad End  SKIDDAW 3054ft (931m)  Barkbethdale  CARL SIDE 2448ft (746m)  Southerndale  LONG SIDE 2408ft (734m)  ULLOCK PIKE 2270ft (692m)

Skiddaw from near Uldale

There are many surprises to be discovered Back o' Skidda but probably none as surprising as Over Water, a small lake set amongst fields along a back road from Uldale.

It serves as a reservoir for the town of Wigton and was created by a dam built in the 1920s. Now owned by the National Trust, and strictly private.

85

## BASSENTHWAITE LAKE

As local wags have it, Bassenthwaite Lake is actually the only true 'lake' in the Lake District. All the others are 'meres' or 'waters'. It's the most northerly lake and one of the largest, a peaceful outpost with no real settlement on its shores. Apart from the A66 blasting along the west side, it's relatively unspoilt. The A595 on the east side winds attractively through woodland on the lower slopes of Skiddaw and is used by mainly local traffic.

Part of the Allerdale Ramble goes along the east shore and walking it is the best way to enjoy the lake environment. Much of the lakeshore has been given over to nature conservation and, apart from yachtsmen, anglers and children at one of the adventure schools, the water is little used. There are no public facilities.

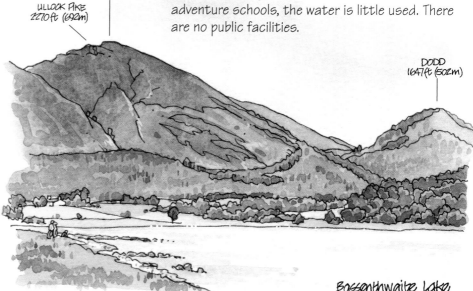

Bassenthwaite Lake

Bassenthwaite Lake
| | |
|---|---|
| Length | 4 miles |
| Maximum width | 0.8 mile |
| Maximum depth | 70ft |

St Begas church occupies an idyllic and lonely situation on the east shore of Bassenthwaite Lake and can only be reached on foot across fields. The building dates from about AD 950, though the site may be older, and was extensively restored in 1874. Christian worship has taken place here for over a thousand years and people travel from all over the world to sample its mystical atmosphere. The church interior is beautifully maintained and always open.

Tennyson is said to have been moved to write his lines about Excaliber while staying nearby at Mirehouse and more recently Melvyn Bragg used St Begas as the setting for his novel *Credo*.

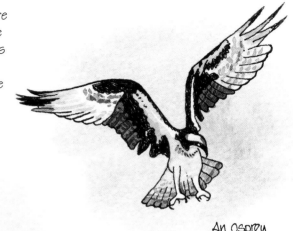

An Osprey

St Begas' church

In 2001 a pair of Ospeys nested near Bassenthwaite Lake, the first pair to do so for at least 150 years. Every year since, Ospreys have made the 3,000-mile journey back from Africa to nest and raise their chicks.

The Lake District Osprey Project operates a viewpoint at the Forestry Commission's Dodd Wood, near Keswick, from where the nest can be viewed through high powered telescopes from a safe distance.

Whinlatter Pass goes from Braithwaite, near Keswick, to High Lorton, at the northern end of the Buttermere valley. As Lakeland passes go it's not particularly high, only just managing to exceed 1,000 feet. For most of the way the outlook is restricted by Whinlatter Forest, but a mile out of Braithwaite there's a break in the trees at a layby and a tremendous view of Skiddaw and Bassenthwaite Lake is revealed.

Derwentwater is just out of sight on the right and in particularly wet periods it's not uncommon for the flatlands between the two lakes to flood turning them into a single huge stretch of water.

Though of lowly stature, Binsey has the distinction of being the northernmost 'Wainwright' fell. Beyond it there are no more Lakeland hills, only the coastal plain and the Solway Firth.

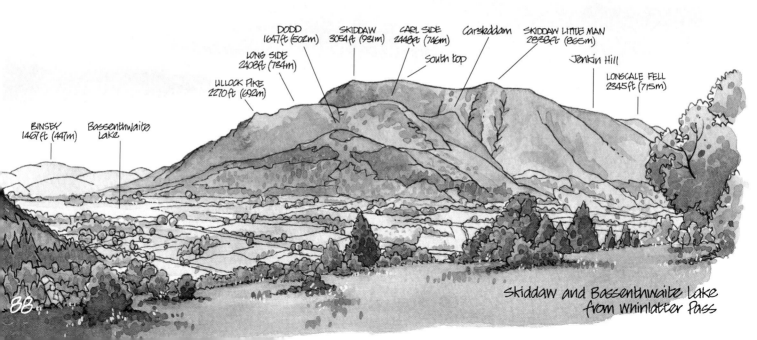

DODD
1647ft (502m)

SKIDDAW
3054ft (931m)

CARL SIDE
2448ft (746m)

Carsleddam

SKIDDAW LITTLE MAN
2838ft (865m)

LONG SIDE
2408ft (734m)

South top

Jenkin Hill

ULLOCK PIKE
2270ft (692m)

LONSCALE FELL
2345ft (715m)

BINSEY
1467ft (447m)

Bassenthwaite Lake

Skiddaw and Bassenthwaite Lake from Whinlatter Pass

BB

# BASSENTHWAITE

With a green, a pub and a river flowing through it, Bassenthwaite is the archetypical English village. But this being the Lake District, there's also two farms within the village itself and many of the houses are holiday lets or second homes. However, snuggled up against the north side of Skiddaw and with the dramatic ridge of Ullock Pike soaring almost from the village streets, Bassenthwaite has a lot going for it.

Apart from the farms selling new-laid eggs, the Sun Inn is the village's only amenity. It's a traditional pub with old beams, real ale and hearty food. There's also a beer garden from where you can watch one of the village's renowned sunsets over Skiddaw.

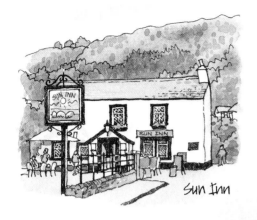

Sun Inn

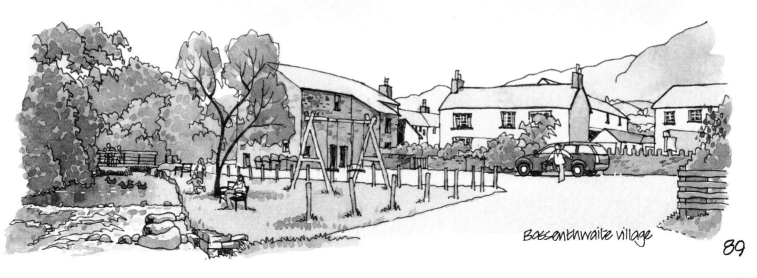

Bassenthwaite village

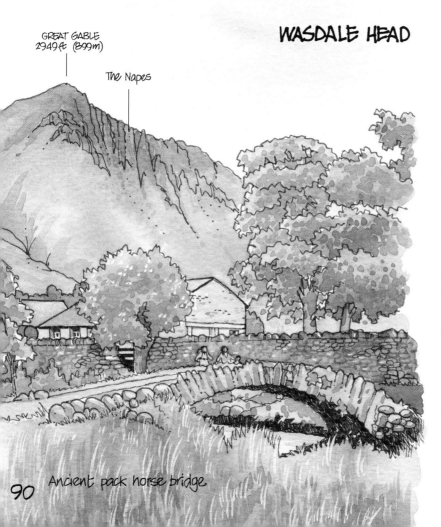

GREAT GABLE
2949ft (899m)

The Napes

# WASDALE HEAD

Ancient pack horse bridge

Best known as the launchpad for the fabulous horseshoe of fells that surrounds it, the tiny hamlet of scattered farms and cottages at Wasdale Head is but a mere spot in this most impressive of Lakeland valleys. Usually reached by a winding road from Gosforth through gentle, pastoral country, the impact of the sudden appearance of massive and rugged mountains can be quite startling. There's nothing of pretty Lakeland here, the landscape is naked, savage and intimidating, but also irresistible and unforgettable. No matter how many times you visit, the impact never seems to diminish.

You can park in the Wasdale Head Inn car park or on a triangular-shaped green on the approach, but on fine days you need to get there early. A small shop in the inn car park sells mainly climbing gear.

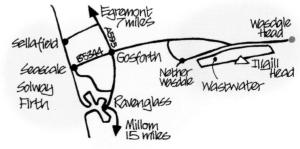

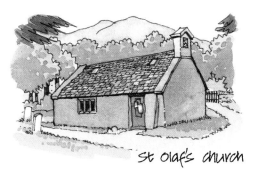

St Olaf's church

Claimed to be the smallest in the country and situated away from the main settlement, St Olaf's church is shrouded by 32 yew trees and has a melancholic air. Roof beams in the rough and ready interior are said to have come from wrecked Viking ships. Climbers who died on the surrounding fells are buried in the small churchyard.

Will Ritson, a larger than life character, was an early landlord of the Wasdale Head Inn, famed for his tall stories. He boasted that Wasdale Head 'had the highest mountain, deepest lake, smallest church and biggest liar in England'. Ritson died at the age of 83 in 1890 but his fame lives on in the name of the public bar at the inn and The 'Biggest Liar in the World" competition held annually at Santon Bridge.

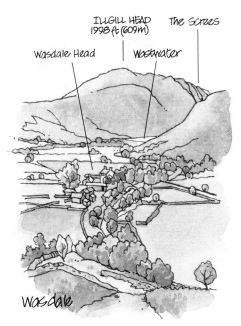

ILLGILL HEAD
1998 ft (609m)    The Screes

Wasdale Head    Wastwater

Wasdale

Wasdale Head Inn

# WASTWATER

The deepest, most dramatic and haunting of all the lakes, Wastwater has an almost total absence of trees to break up its stark outline, stripping the dark waters of all trace of prettiness.

Overshadowing the lake, in every sense, are the awesome Wastwater Screes, an almost 2,000ft (610m) high wall of sharp and shattered rock, slipping in a series of fan-shaped downslopes to the lake bed, 259 feet below the surface.

The classic mountain composition at the head of the valley – Yewbarrow, Great Gable and Lingmell – was adopted as the emblem

KIRK FELL
GREAT GABLE
SCAFELL PIKE
LINGMELL
Styhead
SCAFELL
BROAD CRAG
YEWBARROW
ILLGILL HEAD
CAR PARK
Wasdale Head PARKING services
Small CAR PARK
WASTWATER
The Screes
Gosforth 6 miles
Footpath
Santon Bridge 3 miles
Land Bridge

Wastwater
Length 3 miles
Maximum width 0.5 miles
Maximum depth 259ft

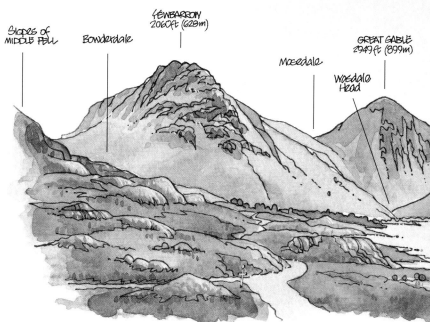

Slopes of MIDDLE FELL
Bowderdale
YEWBARROW 2060ft (628m)
Mosedale
GREAT GABLE 2949ft (899m)
Wasdale Head

of the National Park. England's highest mountain, Scafell Pike, dominates for attention, and Scafell provides a knobbly counterpoint. Championed by the Coronation Street actress, Sally Whittaker, in 2007, ITV viewers voted this 'Britain's Favourite View'.

It's possible to walk all the way round the lake but crossing The Screes is tough going and shouldn't be undertaken lightly, and not at all if you intend to walk with a dog. The sharp rocks will play havoc with the feet of an animal (and those of a badly-shod human too).

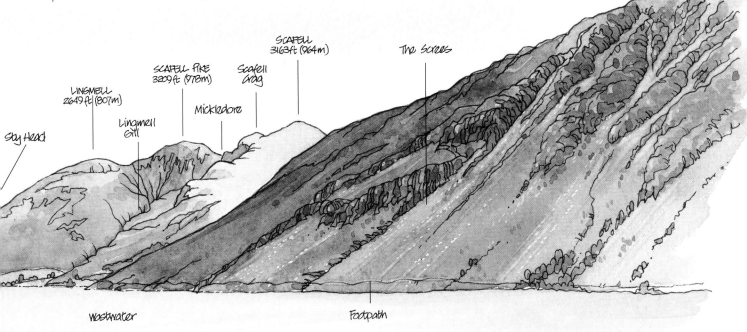

ILLGILL HEAD
1998 ft (609m)

SCAFELL
3163 ft (964m)

The Screes

SCAFELL PIKE
3209 ft (978m)

Scafell
Crag

LINGMELL
2649 ft (807m)

Mickledore

Lingmell
Gill

Sty Head

Wastwater

Footpath

Wastwater & Wasdale from the south-west

93

# FURTHER NOTES

### The Cumbria Way & The Allerdale Ramble

Two long distance footpaths across the Lake District. The Cumbria Way goes south to north for 75 miles between Ulverston to Carlisle. The Allerdale Ramble is 50 miles long, from Seathwaite in Borrowdale to Grune Point on the North Cumbria coast. A guide to the two walks, written and illustrated by Jim Watson, is published by Cicerone Press. Wainwright's Coast to Coast route crosses the Lake District from west to east.

### Lake District National Park

Largest of the English National Parks. Established in 1951 to protect 885 square miles of the Lake District and managed by the Lake District Special Planning Board. It doesn't own the land but has control over planning and development – not always to the liking of local residents. But the board does a worthwhile job preventing inappropriate developments and protecting footpaths and open land. Above the field line you can walk almost anywhere. The fells are public places.

### The Lake Poets

A group of poets who lived in the Lake District at the turn of the 19th century. Though they are all considered part of the Romantic Movement and inspired by the landscape, there was little connection in style between them.

**William Wordsworth (1770-1850)** was the leading light of the group. He was born in Cockermouth and lived in the Lake District for most of his life. His greatest work is considered to be *The Prelude*, a partly autobiographical poem which he revised and expanded a number of times. On the death of Robert Southey in 1843, Wordsworth replaced him as Poet Laureate. His best-know poem is undoubtedly *The Daffodils*. The Wordsworth Trust was

Wordsworth

established to celebrate the works of the poet and his contemporaries through its management of Dove Cottage and The Wordsworth Museum and Art Gallery in Grasmere which are visited by over 70,000 people a year.

**Samuel Taylor Coleridge (1772-1834)** wrote *The Rime of the Ancient Mariner* and *Kubla Khan*. He was a formidable walker and when living at Greta Hall at Keswick would walk to Grasmere to visit the Wordsworths taking in Helvellyn on the way. He eventually left his family, became addicted to opium, moved abroad and died in London.

**Robert Southey (1774-1843)** lived with the Coleridges at Greta Hall. Apart from verse, he wrote the original version of the *Three Bears*, a children's poem about Lodore Falls, and an official history of Brazil without ever visiting the country. A grateful Brazilian government paid for the memorial on his grave in Crosthwaite churchyard, Keswick.

**Thomas De Quincey (1785-1859)** is most famous for writing the *Confessions of an Opium-Eater* from his own experience. An early fan of Wordsworth's, he moved into Dove Cottage when he left it in 1807. De Quincey moved to The Nab overlooking Rydal Water when he married the daughter of the house, but kept on Dove Cottage for 27 years to house his huge collection of books. He became the first editor of the Westmorland Gazette and died in Edinburgh.

### Lakeland Rock

There are three major rock bands across the Lake District which have produced three distinctly different types of scenery. Skiddaw slate in the north is amongst the

oldest rocks in Europe, being created under the sea about 500 million years ago, resulting in Skiddaw's relatively smooth appearance and a shaley consistency underfoot. The central area is dominated by rock formed by violent volcanic action, creating the dramatic, craggy skyline as seen in the Scafells and the Langdale Pikes. A band of Silurian Slates crosses South Lakeland, producing the more rounded hills and the distinctive green slate of the Coniston area.

### The Lakes

Although the number is constantly argued over, there are generally reckoned to be seventeen. In order of size they are: Windermere, Ullswater, Coniston Water, Bassenthwaite Lake, Thirlmere, Haweswater, Derwent Water, Crummock Water, Wastwater, Ennerdale Water, Esthwaite Water, Buttermere, Loweswater, Grasmere, Rydal Water, Brotherswater and Elterwater. The final two cause the controversy. Some say either one, or both, should be categorised as a 'tarn' (see 'The Tarns', page 95) rather than a 'lake'.

The Snooty Fox at Uldale

## The National Trust

Founded in 1895 by the social reformer Octavia Hill, solicitor Robert Hunter and Cumbria churchman Canon Hardwicke Rawnsley. Now governed by a board of trustees and overseen by a council of elected members, the Trust is main funded by almost four million members, the largest membership organisation in the world. It owns, maintains and protects a huge variety of historic houses, gardens, the coast and countryside. The Trust owns or has covenant over about a quarter of the Lake District.

Beatrix Potter

### Beatrix Potter (1866-1943)

Born into a privileged London household, Beatrix was educated by a governess and grew up isolated from other children. On family holidays she developed a love of the Lake District and found solace in wildlife and painting. Her first highly successful children's book, *The Tale of Peter Rabbit,* was published in 1900. She eventually published 23 books, but her later life was devoted to farming, sheep breeding and conservation. She died at the age of 78, leaving 15 farms and 4,000 acres of land to the National Trust, but possibly her greatest legacy has been the hugely successful Beatrix Potter brand.

**Arthur Ransome (1884-1967)** was an author and journalist who wrote the *Swallows and Amazons* series of children's books using Windermere and Coniston Water as a setting for some of the stories. He lived at Coniston 1930-1967 and is buried, with his wife, in the churchyard of St Paul's church, Rusland in the southern Lake District.

**John Ruskin (1819-1900)** Art critic, social thinker, poet, artist and influential writer on art and architecture, Ruskin was the classic Victorian polymath. He first visited the Lake District as a young boy in 1824. In 1871, at the age of 52, he bought the run-down property, Brantwood, on the shores of Coniston Water and spent the rest of his life turning it into a fine country house. It is preserved as a memorial to Ruskin who is buried in Coniston churchyard.

## The Tarns

A tarn is usually regarded as a small lake in an elevated position amongst the fells. It's impossible to tell how many there are as the smallest have no names and some even disappear in dry weather, but there are probably well over a hundred in the Lake District.

Wainwright

### A.W. Wainwright (1907-91)

After being seduced by Lakeland while on holiday, Blackburn-born Alfred Wainwright moved to Kendal in 1942 to work at the town hall, where he became borough treasurer in 1948. Four years later he began to write and illustrate his seven classic guidebooks to the Lakeland fells, a task which dominated the next 14 years. Other books followed, some glossy coffee table editions. Though shy and elusive, in old age he began to appear on television where his quirky personality gradually emerged. Since his death a string of TV programmes on his walks and life has elevated him to cult status.

**Hugh Walpole (1884-1941)** was a prolific New Zealand-born novelist. His most popular books were the four historical romances set in the Lake District, beginning with *Rogue Harris* in 1930. He lived at Brackenburn, on the slopes of Catbells overlooking Derwent Water, where he died, aged 57. Walpole is buried in St John's churchyard, Keswick.

## Weather

Lakeland weather is legendary and not always connected with the facts. It certainly varies from place to place, even changing over short distances, but it's the high places at the heads of the valleys which give the Lake District its reputation for high rainfall. Elsewhere in the area the rainfall is normal to dry for Britain. Keswick has milder winters than London and summers can be hot and sunny. Lakeland weather is unpredictable, which is what makes it so endlessly fascinating. However, venturing on the fells at any time of the year should not be taken lightly. Even on a hot day in Keswick, the top of Skiddaw can be freezing cold. Boots and suitable clothing to keep dry and warm are essential.

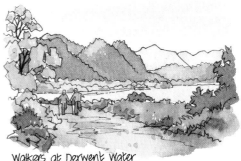

Walkers at Derwent Water

# Also in the Sketchbook series...

A tour of favourite Cotswold towns and villages with more than 200 colour illustrations, history, facts and figures and a few quirky surprises. The perfect guidebook, giftbook or souvenir.

(Published autumn 2010)

SURVIVAL BOOKS

www.survivalbooks.net

*Celebrating the most beautiful regions of Britain*